SUPER SCULPTURE

SUPER SCULPTURE

Using Science, Technology, and Natural Phenomena in Sculpture

Diane B. Chichura
and
Thelma K. Stevens

 Van Nostrand Reinhold Company

New York Cincinnati Toronto London Melbourne

TO LISA, WENDY, AND ANDREW

Acknowledgments

While working on this book we met some great people who went out of their way to help us. Their assistance and cooperation often far exceeded our expectations.

We thank our students at West Hempstead High School, whose work is included in this book. Their pioneering spirit, despite problems encountered in new materials and untried concepts, enabled them to make an outstanding contribution: Brian Abramowski, Maryanne Abramowski, Lance Altneu, Dennis Anfuso, Parise Barbatsuly, Eileen Baxter, Joanne Bellomo, Pat Boussavian, Neil Castellon, Joan Cayton, Gayle Cohen, Myra Cohen, Stacey Cole, Maria Colonna, Dale Cuming, Gladys Feliciano, Abby Goldenberg, Jon Goldman, Jeannine Gomillion, Sonia Gudinsky, Regina Kampf, Pat Kearney, Amy Levine, Chris Lipinski, Steve Martin, Joy Merzer, Laurie Molk, Carol Neir, Mary Orfanitopolos, James Policara, Jeannette Quinto, Pam Rein, Barry Rosenfeld, Diane Rossi, Judy Ruddy, Aida Scaperoth, Linda Schimmel, Joanne Seaman, Jody Seigel, Janet Silkes, Dora Sislian, Karen Smith, Gary Spielfogel, Lynn Stubing, Cathy Weiss, Joanne Yurmanovic, and Maureen Zsiday.

We thank our colleagues who graciously gave their time and knowledge to help solve technical problems: Sylvan Alcabes, William Olyha, Jack Shorr, and Stuart Soman, of West Hempstead High School. We are most grateful to the following for their assistance: Professor David Jacobs, Hofstra University, New York; Professor Lewis Lusardi, State University of New York at Stony Brook; Professors Steven Soreff and James M. Dwyer, C. W. Post College, New York; and to Dr. Melvin Kaplan for sharing his expert knowledge in chemistry.

Our appreciation to Sheila Brummel, Harriet Levine, and Joe Frica for their help. For their generous cooperation we wish to thank the museum and gallery personnel who gave their time and attention. Special thanks to Joe Bodolai of the Electric Gallery, Toronto, Canada, for his interest.

And finally, our thanks to our husbands, Jay and Gene, whose special contributions, understanding and encouragement, helped immeasurably.

Van Nostrand Reinhold Company Regional Offices:
New York Cincinnati Chicago Millbrae Dallas

Van Nostrand Reinhold Company International Offices:
London Toronto Melbourne

Copyright © 1974 by Litton Educational Publishing, Inc.
Library of Congress Catalog Card Number 73-16703
ISBN 0-442-21542-8

Designed by Elaine M. Gongora

Published by Van Nostrand Reinhold Company
A Division of Litton Educational Publishing, Inc.
450 West 33rd Street, New York, N.Y. 10001

16 15 14 13 12 11 10 9 8 7 6 5 4 3 2 1

Library of Congress Cataloging in Publication Data

Chichura, Diane B 1932-
 Super sculpture; using science, technology, and natural phenomena in sculpture.

 Bibliography: p.
 1. Kinetic sculpture. I. Stevens, Thelma K., 1932- joint author. II. Title.
NB1272.C49 735'.29 73-16703
ISBN 0-442-21542-8

Fiber Optic Sculpture, electric light source, fiber optic light guides, and plastic.

Wen-Ying Tsai, *Cybernetic Sculpture*, 1970, stainless steel, electronic circuitry, strobe lighting, height 96". The Electric Gallery, Toronto, Canada. (Photograph by Gertrude Marbach-Rau)

John Harris, *Dome Mirror*, Mylar plastic dome. Courtesy of the artist.

(Photograph by Fortune Monte)

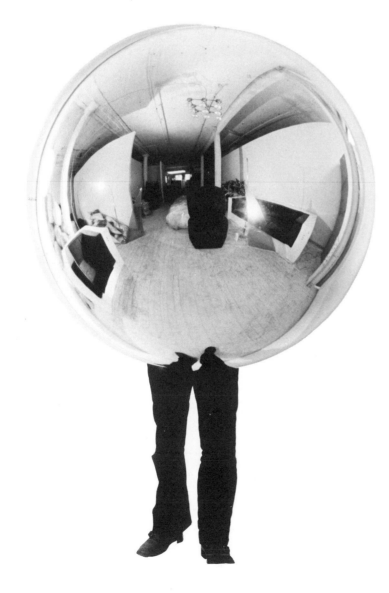

CONTRIBUTING ARTISTS

William Accorsi
Elliott Barowitz
Bernard Baschet
François Baschet
Rachel bas-Cohain
Mary Bauermeister
Feliciano Béjar
Robert Breer
Pol Bury
Juan Luis Bunuel
Alexander Calder
Aaronel de Roy Gruber
Hans Haacke
John Harris
John Healey
David Jacobs
Lewis Lusardi
Sam Markle
George Odom, III
Claes Oldenburg
Adam Peiperl
Attilio Pierelli
Man Ray
Robert Rauschenberg
Jose de Rivera
Larry Rivers
Salvatore Romano
Nicholas Schoffer
Robert Sullins
Jean Tinguely
Wen-Ying Tsai
Takis Vassilakis
Roger Vilder
Tony Fugate Wilcox
Albert Wilson
Adrianne Wortzel

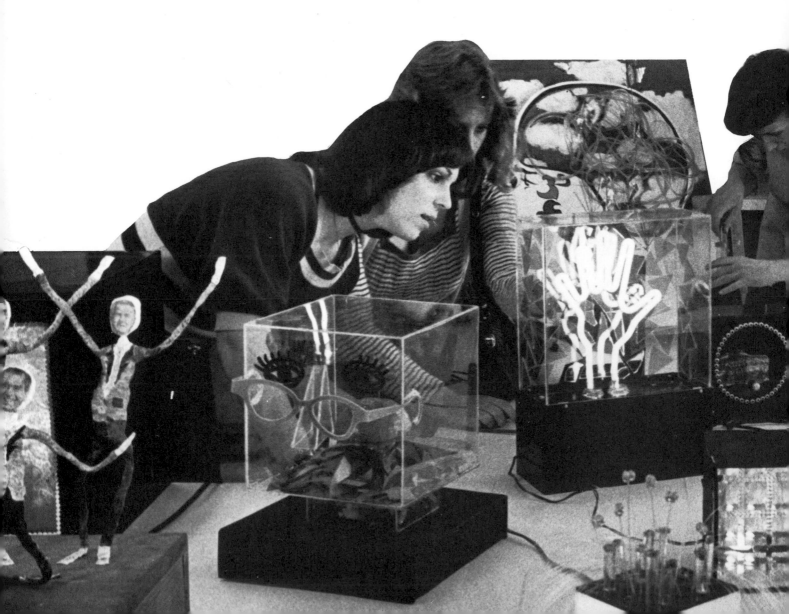

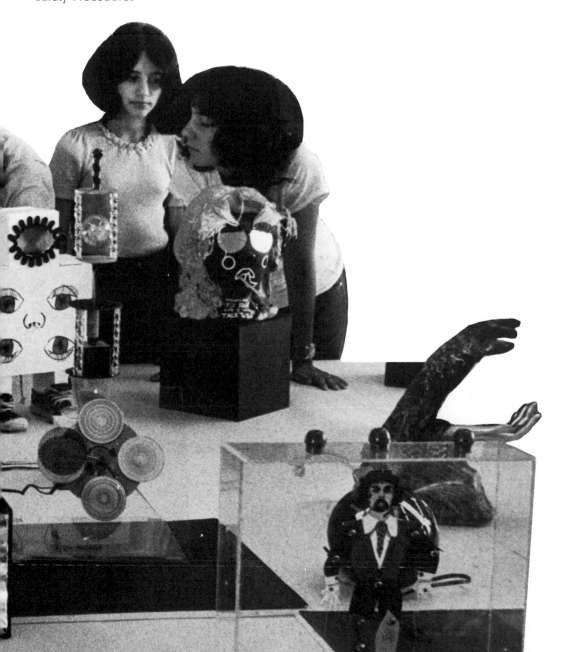

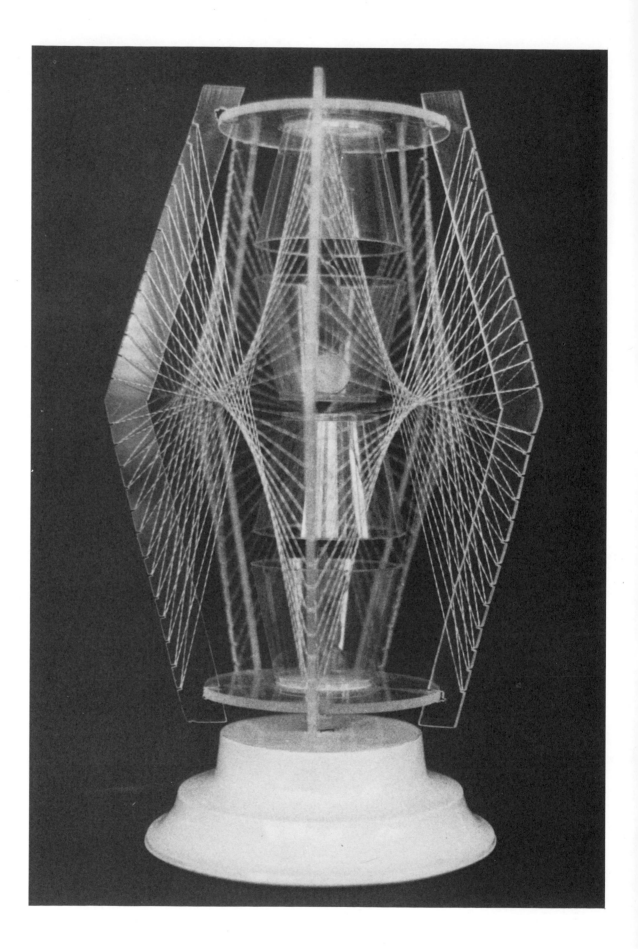

Introduction

This book is for teachers and young artists. Our goal was to produce a practical approach to kinetic sculpture to help students and teachers experiment with confidence in the use of new concepts and materials.

Today's young person has grown up in an environment filled with excesses of sound and of light. We found that our students were uninspired by traditional materials and approaches. They did not realize what exciting developments are going on in the art world — that artists are using unusual materials and working in so many different directions. The excitement of these innovations had to be brought to the classroom.

Our definition of kinetic sculpture is broad: it includes any sculpture which is involved in the process of change — any sculpture which is not static. It can move, light, grow, expand, fuse, or make a sound. The energy needed for change may be natural, mechanical, electrical, or chemical. The change itself may take a fraction of a second, or it may take centuries.

Part One of this book offers background information about kinetic sculpture: its history, the broad scope of contempoary developments, and its application in the classroom. Part Two shows a great variety of fairly easy approaches to kinetic sculpture, and will help the reader understand some of the problems our students encountered and how they were solved.

The young artist should understand that there is no one formula for creating a kinetic sculpture. Nor does the artist, alone, necessarily possess all the information vital to the completion of his work. He is encouraged in this book to seek help and technical know-how from others, as the need arises.

We have tried to use a basically motivational approach and to offer our reader a great number of suggestions for creative exploration. If you are willing to explore new concepts in art, we hope this book provides the direction. Free yourself and begin!

Opposite:
Linear Construction, plastic, found objects, fishing line, and revolving electric motor.

Left:
Wind Flowers, flooring nails, tin cans, and steel rods.

A NEW LOOK

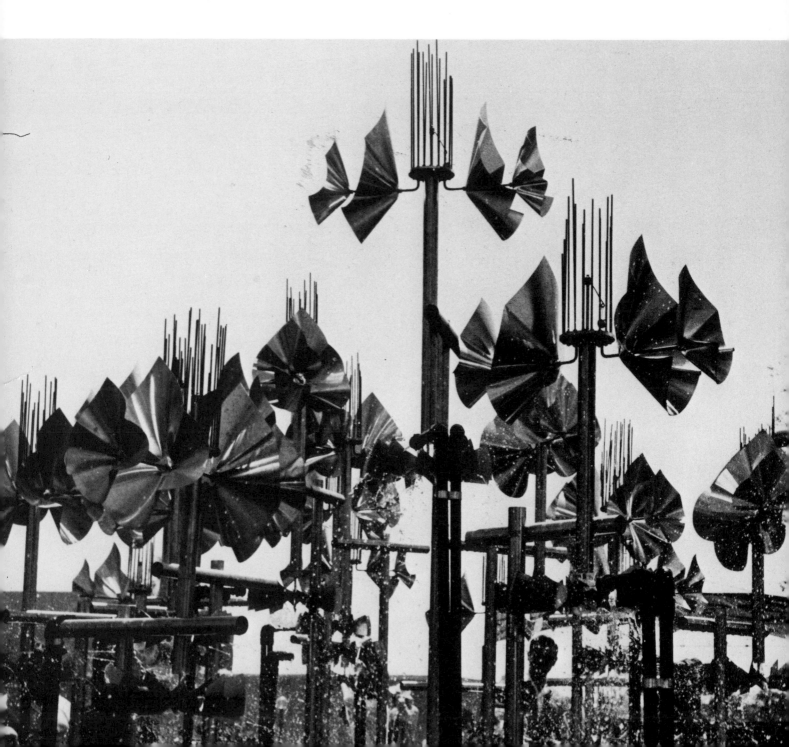

chapter 1
What's It All About?

Sculpture that constantly changes; sculpture that communicates; super-sculpture that reaches our senses with light, sound, and action — this is the sculpture of the space age.

Today, there are no limits to the possibilities for sculptural expression. One of the most important developments in modern sculpture is the use of natural, mechanical, electrical, and chemical energy to create action in sculpture. No longer does a piece of sculpture have to be motionless or be made of a hard material like marble. It can move, make a noise, or light up. It can communicate with, and respond to, the viewer. Modern sculptors encourage us to touch and be part of their art expression. They want us to operate cranks and buttons, touch and feel textures, and react to blinking lights and noises.

Do you remember when a piece of sculpture used to stand in one place — when there were specific materials a sculptor might use? Until recent times, clay, stone, wood, and metal were the traditional materials used for finished sculpture. Static forms and styles were dictated by artistic convention.

New varieties of materials have transformed today's art. The use of plastics

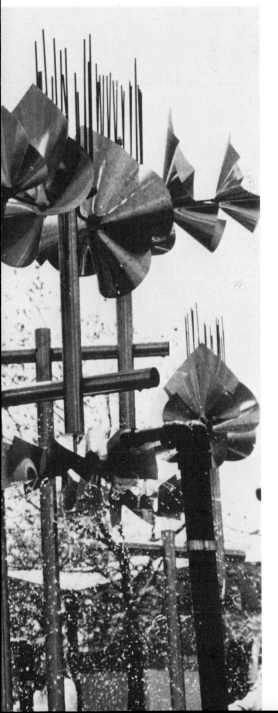

François and Bernard Baschet, HemisFair 68 Fountain, San Antonio, Texas, stainless steel. In this musical fountain both sound and water jets can be controlled by the public. Waddell Gallery, New York.

Juan Luis Bunuel, *Too Many Pigs,* bronze, brass wire, and copper, height 18″. This whimsical mechanical sculpture is put into action by turning a crank. Willard Gallery, New York.

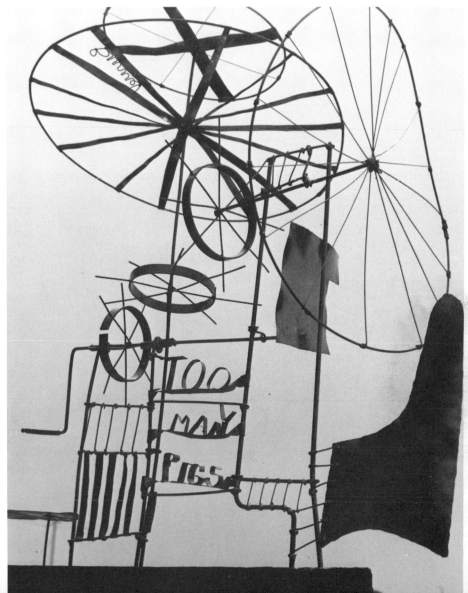

Wen-Ying Tsai, *Cybernetic Sculpture,* stainless steel rods, strobe lights and electronic equipment. Electronically controlled steel rods are activated by noise and movement in the surrounding environment. This sculpture won an award in the American Iron and Steel Institute's Design in Steel Award Program for 1972–73. (Photograph by Gertrude Marbach-Rau)

Jean Tinguely, *Le Rotozaza #1*, 1967, iron, wood, rubber balls, and motorized elements, 87" x 162" x 92". The spectator participates in this sculptural expression as he feeds rubber balls back into the sculpture. Alexandre Iolas Gallery, Paris. (Photograph by André Morain)

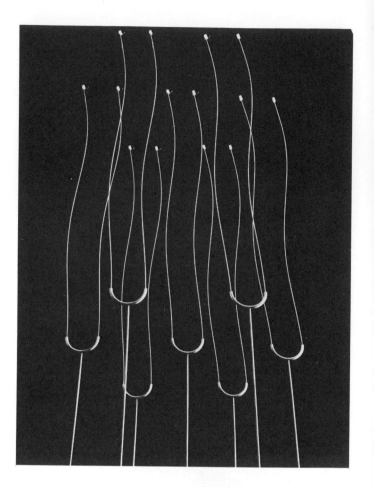

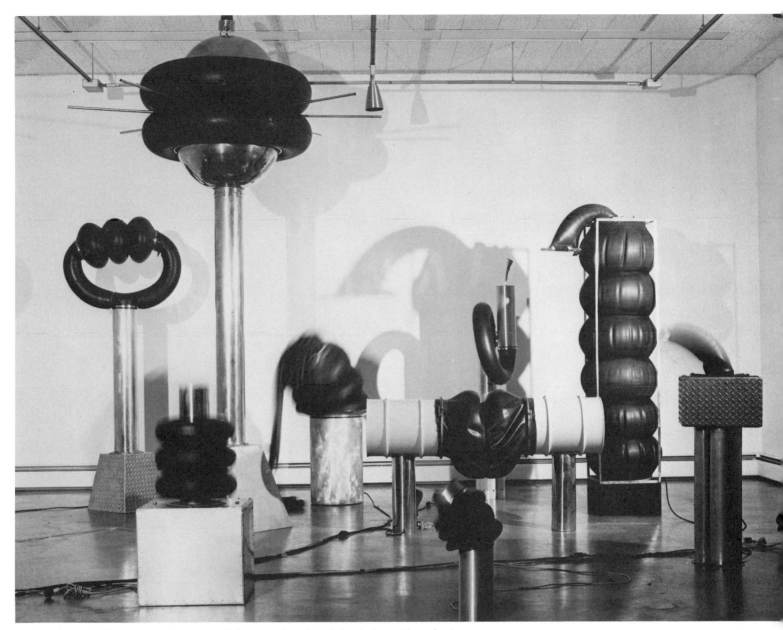

David Jacobs, *Wah Chang Box Works*, 1967, steel drums, gaskets, baker's bowls, inner tubes, aluminum, electric fan, and sounding reeds. This group of nine inflatable sound sculptures is programmed to present a performance: when presented with lights, films, slides, and other sounds the individual pieces make noise, move, and seem to react to one another. (Photograph by Michael Fales)

permits the creation of sculptures which are transparent or even inflatable. Now sculptures can float, or lean and sway in the breeze. They need not necessarily stand on a pedestal; they may be constructed without any base at all. They can be made of soft materials and their form can change as they move from place to place.

Modern industrial techniques have also contributed to a change in the character of today's art. Sculptors have adapted methods used in the construc-tion of buildings and bridges to their individual designs. Such industrial processes as welding and riveting, in addition to the use of epoxy cements, permit the construction of sculptures using unconventional materials. Today, a single piece of sculpture may combine the use of metals, plastics, found objects, woods, stones, synthetics, and glass. These sculptures are durable and they are capable of continued action. Moving like machines, they reflect the reality of today's world.

The machine itself has been the source of inspiration for much of today's sculpture. Sometimes the artist intentionally makes his sculpture self-destructive, to remind us of the obsolescence of all machinery.

Sculptors are facinated by the changes wrought by chemical action. They find that with this technical knowledge they can alter the basic structure of a sculpture. The reaction of liquids to each other, the effect of temperature changes, and the processes of growth

Right:
Hans Haacke, *Sky Line III*, October 29, 1967, Sheep Meadow, Central Park, New York. A string of white helium-filled balloons on nylon line in the prevailing winds. (Photograph by Hans Haacke)

Below left:
Larry Rivers, *Don't Fall*, 1966, plastic and neon lights. This sculpture uses neon lights in combination with plastic to create an electric construction. Marlborough-Gerson Gallery, New York.

Below right:
Aaronel de Roy Gruber, *Reverse Motion Cube*, 1969, acrylic plastic and motorized elements, 48" x 16" x 16". A plastic cube with concave and convex sides is balanced on one corner and rotates on a similar cube. Bertha Schaefer Gallery, New York. (Photograph by Jacob Malezi)

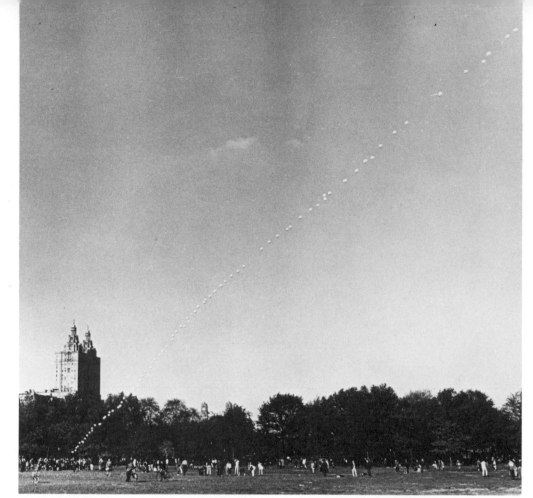

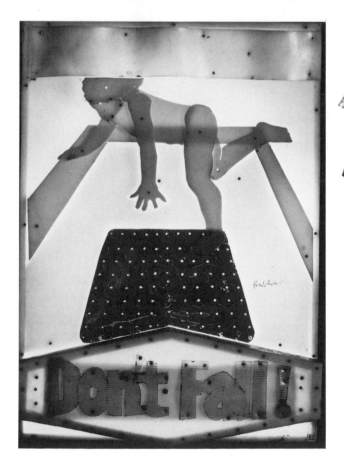

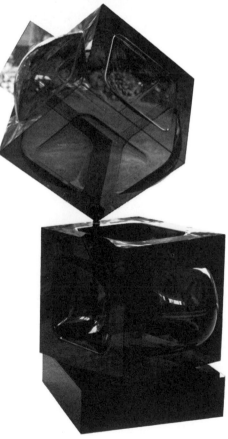

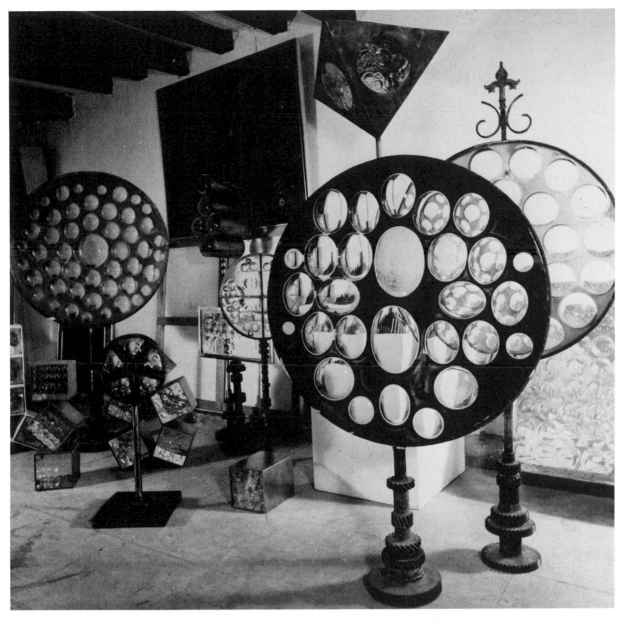

Feliciano Béjar, *Magiscopes*, plastic, crystal, metal, and mirrors. The mirrors and optical elements of these sculptures distort and change the environment as the viewer looks through them. Bertha Schaefer Gallery, New York.

have now become a part of sculptural expression. Some contemporary sculptures are actually alive and in a continual process of natural growth. Others can change in structure from a liquid to a solid state. Can you imagine a sculpture which alternately freezes and liquefies?

In recent years, large companies have encouraged and financed the collaboration of artists with scientists and engineers. Sculptors have thus experimented with new materials and a highly sophisticated technology. This includes experimentation with computers, lasers,

strobe lights, closed circuit television, audio-tape recordings, and various cybernetic devices. The resulting sculptures are of great technical complexity. Some are programmed to react to light, movement, and noise in their environment.

The new sculpture has caused much controversy and puzzlement. There are those who say, "It is not art." Yet, the artist has always been the rare person who recognizes the potential in his environment and sees beyond his time. He questions, explores, and makes aesthet-

ic statements about his changing society. He uses modern technology to communicate his inner feelings about our multi-media age.

The sculpture of our time is not always easy to understand. Judgments about the validity of current art expression need not be made; it is important to remain open-minded and tolerant of artistic developments. Artists should be given a fair chance, and each sculpture should be viewed as a sincere attempt to communicate.

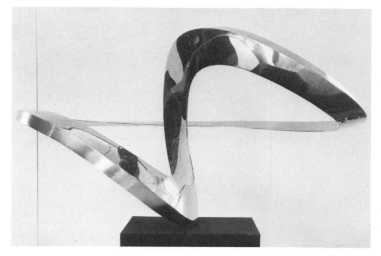

José de Rivera, *Construction #127,* 1970, stainless steel sheet, 18" x 34" x 30". A graceful stainless steel curve changes slowly as it rotates on its base. Grace Borgenicht Gallery, New York. (Photograph by Walter Rosenblum)

Hans Haacke, *Ice Table,* 1967, refrigeration unit, cooling plate, housing, and room moisture, 36" x 36" x 18". The top surface of this sculpture, which freezes and liquifies, responds to changes of climate in the area of display. (Photograph by Hans Haacke)

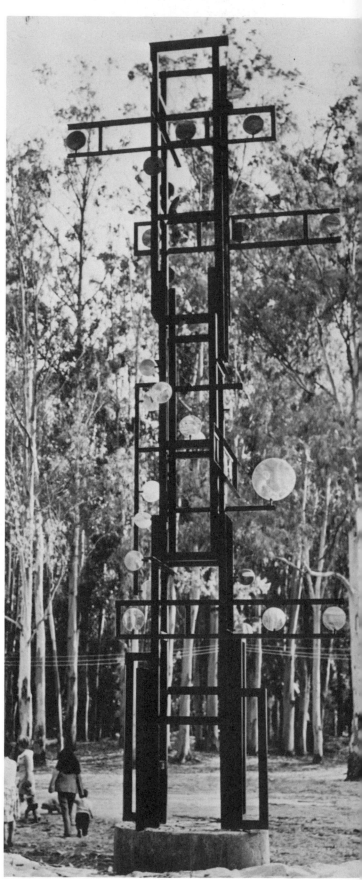

Nicolas Schoffer, *Chronos 8,* stainless steel and motorized elements, Montevideo, Uruguay. This revolving sculpture has lights which blink on and off. The many reflecting surfaces shimmer and flash as they move. Denise René Gallery, New York. (Photograph by Alfredo Testoni)

chapter 2
Who Started It?

Imagine standing in the throne room of a castle during Leonardo da Vinci's time. A mechanical lion suddenly appears, walks across the room, and offers flowers to the king. The courtiers cheer at this miraculous sculptural invention by Leonardo, the master artist-engineer. Is this lion a sculpture or a scientific invention? Certainly, it is an object of artistic beauty with the added dimension of movement. This combination of art and technology could be considered a kinetic sculpture of its time.

Man has always been facinated with anything lifelike — anything that imitates human or natural behavior. From earliest times artists have designed moving sculptures which delighted and mystified the viewer. Small clay figures which could move were found in Egyptian tombs. The ancient Greeks were reported to have created a bird that could fly. A German astronomer designed an iron fly that could flutter around the room then return to its original position. Fantastic tales are told of the singing birds found in the Chinese Imperial Courts; in ancient India, mechanical elephants moved to music, while mechanical parrots and monkeys

Jaquet-Droz, *The Musician*, 1774, automation. Musée de la ville de Neuchâtel, Switzerland.

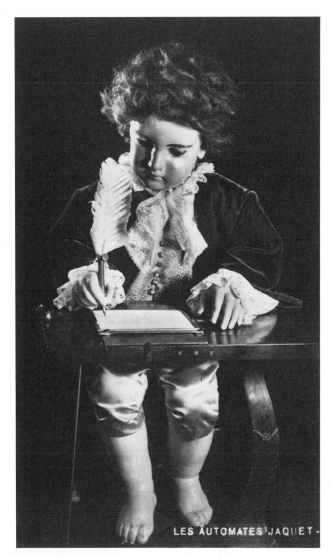

Jaquet-Droz, *The Writer*, 1774, automation. Musée de la ville de Neuchâtel, Switzerland. These lifelike figures have complex mechanisms within them. They imitate life by breathing, bowing, and moving their eyes and heads. They are still functioning today.

chirped and chattered away. Energy to move these kinetic sculptures of long ago was provided by natural or mechanical means. Air or water, when compressed mechanically or expanded by heat, could produce sounds and voices.

The artist often sought to actively involve the viewer and capture his attention. He frightened, entertained, surprised, and awed his audience. In the Middle Ages, ghosts would appear suddenly at castle windows. Water fountains in the gardens would unexpectedly start and drench a casual stroller. In the fourteenth century, Charles VI, king of France, commissioned a spectacular display for the crowning of his queen: a bejewelled white stag was created that could move its head and eyes and its hooves, as well as carry a sword; an angel glided down from the heights of Notre-Dame and placed the crown on the queen's head.

Technical progress led to the construction of more complicated sculpture. Many of these were mechanical figures imitating human behavior. Visualize an eighteenth-century mechanical figure — she moves her fingers and plays an organ; she breathes, her eyes follow the music, and she bows after each piece. Complicated fountains, clocks, and dancing dolls — many activated by spring mechanisms — were other popular expressions of this kind of sculpture.

Experimentation with light as an art medium began in the nineteenth century. Artists tried to produce color, form, and motion with light. With the invention of electricity, even better results were obtained. In 1905, Thomas Wilfred mastered the controlled movement of light, which he projected on a translucent surface. He called this art *Lumia*. Sometimes, he added music to these programmed light sculptures.

Mechanical clock on the tower of the Town Hall in Munich, Germany, 1908. When the clock on the town hall strikes 11 A.M., the figures turn, dance, and nod their heads. German Information Center.

Gerard Comagni, *Sand Toy*, 1850. The arms of these painted musicians are put into motion by sand that drops down on a power wheel. Museum of the City of New York.

Mechanized sailing ship, 1840 brass clockwork mechanism. This mechanical windup ship rocks back and forth in the painted shadow box. Museum of the City of New York.

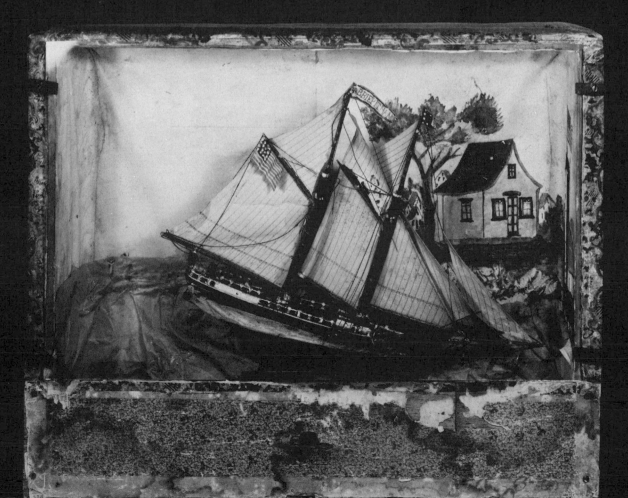

The effects of motion, speed, and mass production are evident in the works of such artists as Marcel Duchamp and Man Ray. No longer were these artists interested in making wood or marble look like skin — using materials to imitate reality. They believed that the material of the sculpture was important in itself. For the first time, commonplace, or ready-made articles — a bicycle wheel, a coat hanger, or perhaps a metronome — became the material for sculpture. The use of these everyday objects, in combination with electrical and mechanical movement, was an important development in kinetic art.

Alexander Calder, trained as an engineer, has always been intrigued with the possibilities of motion in art. He has experimented with moving sculptures which make use of motors, as well as hand cranks. He is most famous for his mobiles and stabiles which are delicately balanced constructions, set into motion by touch or air currents.

The relationship of the artist to the technology of his age has always been evident. In recent years, as technology has become more sophisticated, the artist has responded with increasingly complex sculptures.

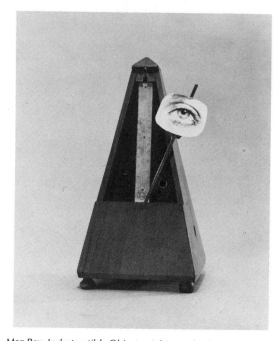

Man Ray, *Indestructible Object or (object to be destroyed)* 1964. (Replica, after a 1923 original was destroyed in 1957.) Metronome with cutout photograph of eye on pendulum, 8⅞" × 4¾" × 4⅝". Collection, The Museum of Modern Art, New York. James Thrall Soby Fund.

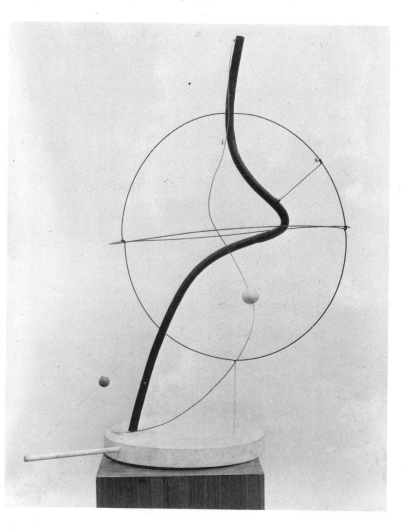

Alexander Calder, *A Universe*, 1934, motorized mobile; painted iron pipe, wire, and wood with string, height 40½". Collection, The Museum of Modern Art, New York. Gift of Abby Aldrich Rockefeller (by exchange).

chapter 3

Where Is the Action?

SCULPTURES THAT RESPOND TO THE VIEWER

A large white dome moves slowly towards you. Touch it, and it mysteriously reverses its direction. This sculpture, Robert Breer's *Osaka I*, is six feet high and six feet in diameter. It is propelled by a motor which has a forward speed of eleven inches per minute. The sculpture automatically reverses direction when it makes contact with another object.

You enter a darkened room. The sound of your footsteps causes flashes of light on one wall of the room. Stamp your foot and the entire wall lights up, revealing images of chairs. This is Robert Rauschenberg's *Soundings,* a sculpture that responds to people. Raise your voice, clap your hands and you become a part of the action.

It is 1975, in Paris. You look across the city and are astounded by a huge sculptural construction which is taller than the Eiffel Tower. Watch it carefully and you will see it move and send out changing light and sound signals; it is responding to the noise and activity around you — an incredible sight! This is Nicholas Schoffer's *Cybernetic Tower of Light*, one of the largest, most complex sculptures ever planned. The underground brain center of this steel structure will control multi-colored projectors, electronic flashes, revolving mir-

Robert Breer, *Osaka I,* 1970, fiber glass, steel chassis, 24 volts direct current motor. These sculptures were two of eight floats at the Art and Technology Pavilion, Expo 70, Osaka, Japan. Courtesy of the artist. (Photograph by Shunk-Kender)

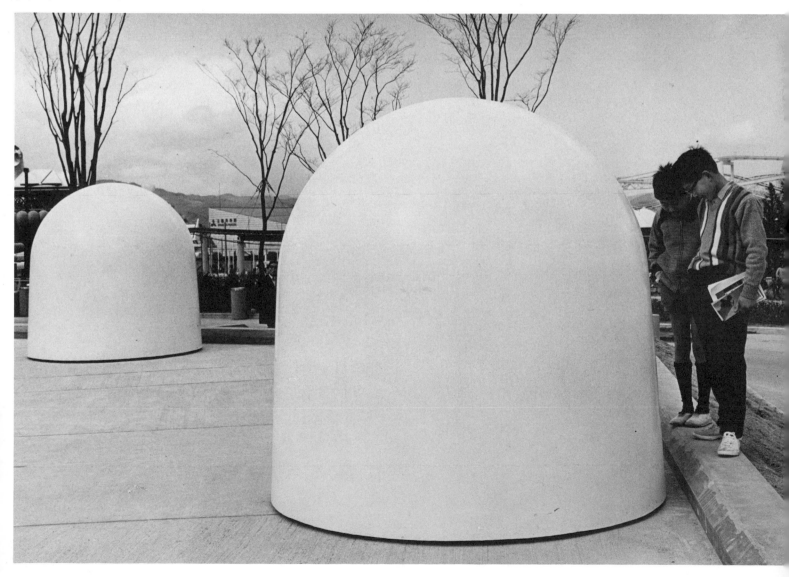

rors, and lasers. These will react to temperature changes, traffic jams, and all city activity with constantly changing light signals, sounds, and movement.

The steel rods of *Cybernetic Sculpture* seem to dance and sway with a life of their own. Wen-Ying Tsai, an engineer who later became a kinetic sculptor, uses engineering principles to create exciting works of art. Such stainless steel sculptures combine strobe lights and electronic equipment to create vibrating movement — they invite the viewer to participate in their action. Sometimes the nearness of the spectator, and the sounds around the sculpture, cause the movement to change from slow to rapid vibrations. Cybernetic sculptures behave like "living sculptures." They are programmed to respond to people or the environment around them. They tend to react to changes of light, movement, or noise.

Robert Breer, *Osaka I,* Inside view of motorized elements of the sculpture. Galeria Bonino, New York.

Robert Rauschenberg, *Soundings,* 1968, 8' x 36' x 54", (three rows of nine panels each), silk-screen ink on Plexiglas with electronic equipment. Wallraf-Richartz Museum, Cologne, Germany, collection of Sammlung Ludwig. (Photograph by Leo Castelli Gallery, New York)

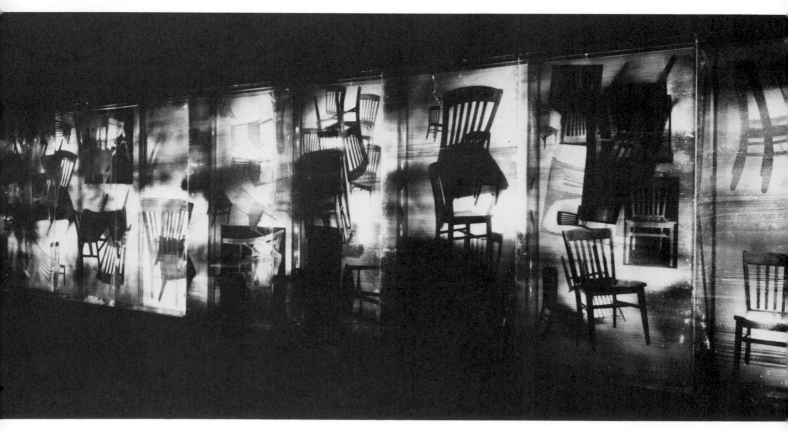

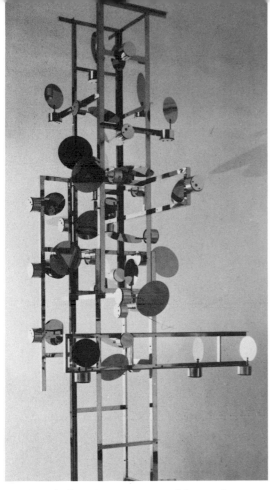

Nicholas Schoffer, *Chronos 8*, 1967, stainless steel, motors, height 118½". Denise René Gallery.

Nicholas Schoffer, *Cronos 8*, shown in motion.

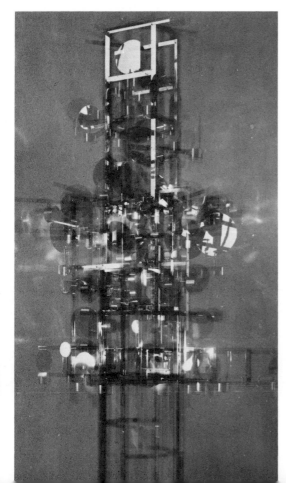

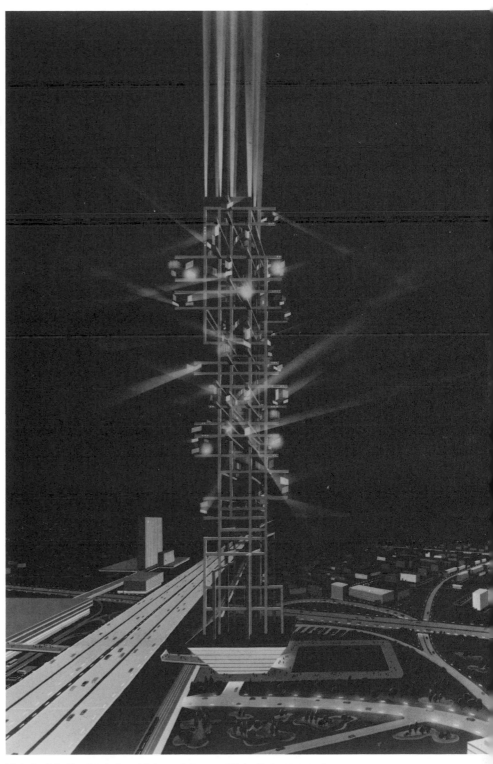

Nicholas Schoffer, Rendering of *Cybernetic Tower of Light*, Paris, proposed for completion in 1975, stainless steel, projectors, electronic flashes, mirrors, lasers, underground cybernetic center. Denise René Gallery, New York.

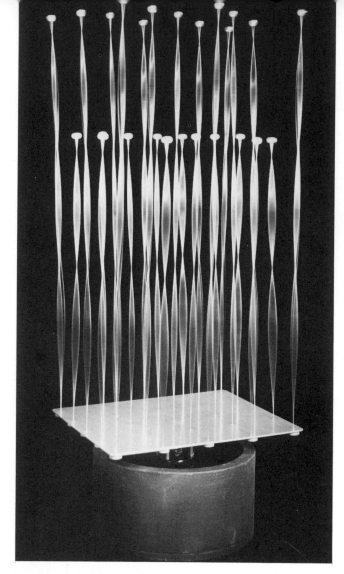

Wen-Ying Tsai, *Cybernetic Sculpture,* 1970, steel, electronic circuitry, strobe lighting, 72" x 36". The Electric Gallery, Toronto, Canada. (Photograph by Gertrude Marbach-Rau)

Claes Oldenburg, *Ice Bag, Scale B,* 1971, (similar but smaller than *Ice Bag* at Expo 70), yellow nylon, fiberglass, motor, height 1040", diameter 48". Produced by Gemco, Gemini G.E.L., California. Sidney Janis Gallery, New York. (Photograph by Hannah Wilke)

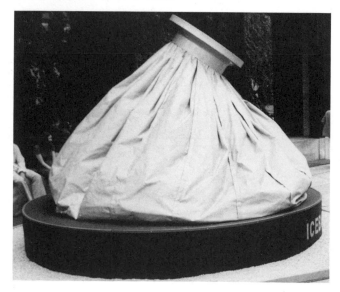

David Jacobs, *Wah Wah Siren,* 1967, rubber, aluminum, electrical fan, sounding reeds, height at rest 36", inflated 68". This composite (double-exposure) photograph shows an inflatable sound sculpture at rest and fully inflated. (Photograph by Michael Fales)

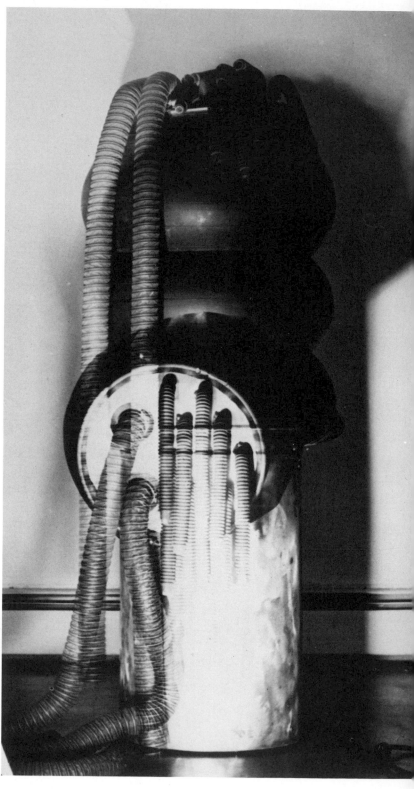

24

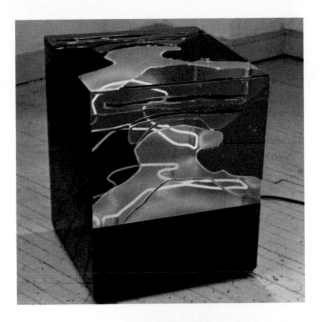

Elliot Barowitz, Boxed-Double Landscape, 1970, transparent acrylic plastic, steel, aluminum, and two neon units, 32" x 23½" x 23½". Courtesy of the artist.

George Odom III, ODOMated Fiber optics. Two stills from a twenty-five minute programmed fiber optic composition. (Photograph by Winfield Swanton)

Lewis Lusardi, Tribute to Wilfred, Mylar reflectors. Courtesy of the artist.

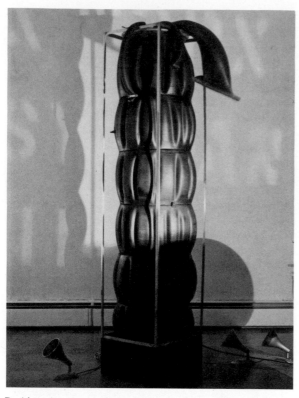 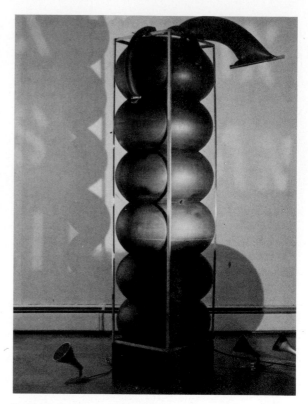

David Jacobs, *Dancer*, 1967, rubber, aluminum, electrical fan, sounding reeds, height 74". (Photograph by Michael Fales)

David Jacobs, *Dancer*, inflated view.

INFLATABLE SCULPTURES

A huge red *Ice Bag* that appears to dance as it inflates and deflates was designed by Claes Oldenburg. This soft sculpture, made of vinyl, rises from seven to sixteen feet. It represented American art at the Expo 70 world's fair in Osaka, Japan. In collaboration with industry, Oldenburg constructed many models for the *Ice Bag* sculpture. This process involved experimenting with different mechanical devices until he found the movement that best suited his design. The final sculpture was powered with a hydraulic motor.

The *Wah Wahs* of David Jacobs are sculptures that moan and groan, inflate and deflate. These sound sculptures have an electric blower concealed in the base which causes the rubber to inflate. As the sculpture begins to rise, it emits sounds from several reeds or tubes activated by the escaping air. To create his sculptures, David Jacobs has consulted with engineers, electricians, and even the owner of the corner garage.

SCULPTURES USING LIGHT

Light becomes the art material in Sam Markle's *Still Life#1*. His bright neon flower, in a Coke-bottle vase, combines light with a typical commercial object. Sam Markle is a craftsman who operates a well-known Toronto neon-sign business. He has applied his knowledge of bending glass tubes and filling them with neon gas into a whimsical art form.

Elliot Barowitz has constructed a three-dimensional landscape painting using neon light and plastics. In *Boxed-Double Landscape* (see page 25), brilliantly colored neon tubing glows from within a multi-colored enclosure. This is another example of the artist using modern industrial products for his art expression.

The properties of fiber optics, once a medical and technical tool, are now being used for kinetic light sculptures. With this long plastic tube, called a fiber optic light guide, light can be transmitted so that it emerges brightly wherever the tube ends. George Odom III, in his *ODOMated Fiber Optics* (see page 25), creates constantly changing colored images which give the effect of a sculptural painting in motion. Shown in front view are two different phases of its program, which lasts twenty-five minutes. The rear view shows how the light guides transmit the color patterns from a revolving disc to a translucent screen on the front of the sculpture.

Lewis Lusardi is another artist who uses plastic light guides to create changing light patterns. In his *Fiber Optic One*, intense points of light from a hidden source are transmitted through these guides to the screen. They glow and sparkle as they move in controlled sequences. As the viewer watches the screen in *Manhattan* (see page 36) by the same artist, he sees an unusual color and light composition of a city. This sculpture is constructed with prisms and masks. The illuminated forms are fixed, but they appear to move, as shadows expand and brilliant colors change their hues.

Changing luminous forms are pro-

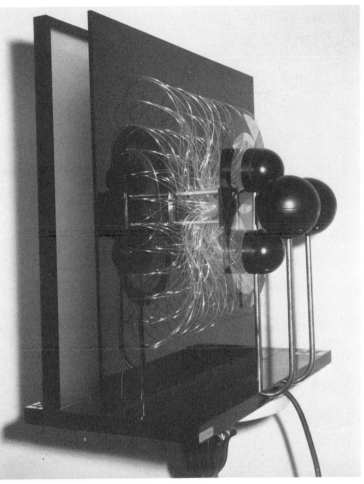

George Odom III, *ODOMated Fiber Optics* (rear view). Courtesy of the artist.

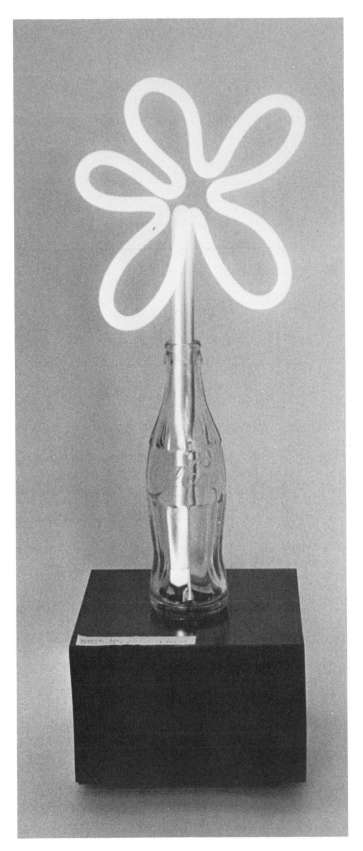

Sam Markle, *Still Life #1*, 1970, neon, 6½" x 6½" x 20". The Electric Gallery, Toronto, Canada

Lewis Lusardi, *Fiber Optic One,* Courtesy of the artist.

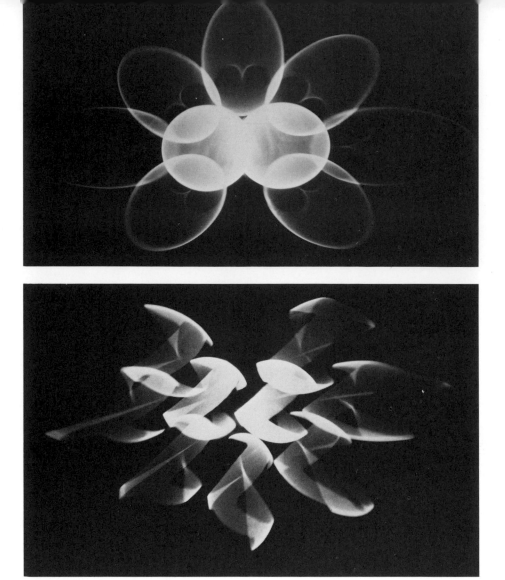

jected on to a translucent screen in John Healey's *Box 3* light sculpture. The two compositions shown are examples of the endless variety of symmetrical patterns that appear. These images transform themselves slowly and gracefully as they move across the screen. All mechanisms are enclosed and hidden in the boxlike construction.

Adam Peiperl's sculptures use the properties of polarized light. In *Astralite 3* (see page 36), clear plastic shapes move in a sealed, liquid-filled container which is placed before polarized light. The movement is caused by a motor which creates currents in the liquid. While the plastic shapes are in motion, continually changing spectral colors can be seen in them. *Origin* (see page 36) is a freestanding plastic sculpture which turns slowly while brilliant colors are constantly changing on its curved surfaces. Adam Peiperl, a former chemist, has combined science and art to create vivid kinetic sculptures of rainbow colors.

John Healey, *Box 3*, 1967, lights, lenses, pattern discs, and color wheels, 24" x 38", Waddell Gallery, New York.

John Healey, *Box 3*, one of many variations.

François and Bernard Baschet, *Windmill*, 1967, steel and aluminum, height 24½". Waddell Gallery, New York. Collection of Carl Steele.

MUSICAL SCULPTURES

Anyone can play music on the sculptures designed by the Baschet brothers. These sculptors feel that our computerized society does not offer ways for individuals to express themselves. As a result, they have designed huge musical fountains with both sound and water jets, which can be controlled by the public. The musical windmills and fountains of the Baschet brothers produce sounds that resemble oriental wind chimes. In *Windmill*, which is made of stainless steel and aluminum, there are three amplifiers to carry the sound. This sculpture needs only to be stirred by a breeze, or rocked gently by hand, to produce pleasant and soothing music.

The moving parts of Albert Wilson's *Pump a Tune* sculpture are all in view and they, too, invite the spectator to join in the fun. Sounds can be created with pumps and pedals as the viewer becomes involved with the mechanisms.

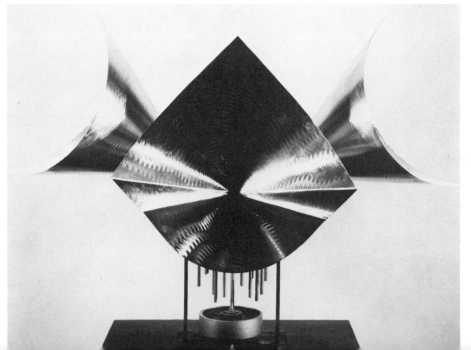

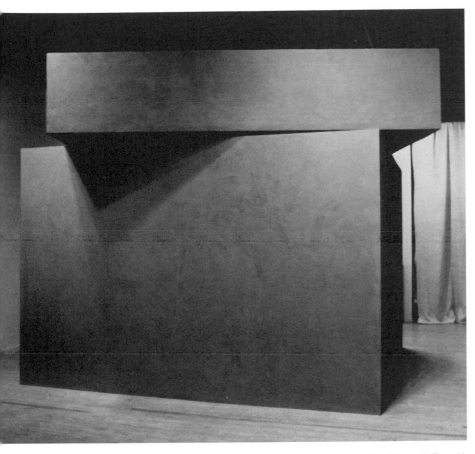

SCULPTURES ACTIVATED BY AIR CURRENTS

A huge blue rectangular solid with a moving lid commands your attention. This sculpture is Salvatore Romano's *Sliding Blue.* As you look up at the lid, sometimes you find it settled squarely on the base, while at other times it slides slowly around. This moving top floats on a pool of water and any air current will set it into motion.

Attilio Pierelli's *Saturno I* dominates the landscape with its rocket-like form. It balances on a roly-poly base and responds to wind currents with a rocking motion.

Dollar bills are used as the art material in John Harris's *Cash Flow.* The money, which circulates in a clear plastic sphere, is put into action by air currents from an electric fan.

Salvatore M. Romano, *Sliding Blue 1970,* steel and water, 12' x 12' x 10½', Max Hutchinson Gallery, New York. (Photograph by J. Saltzero)

Albert Wilson, *Pump a Tune,* 1970, steel, 24" x 15" x 24". Albright-Knox Art Gallery, Buffalo, New York.

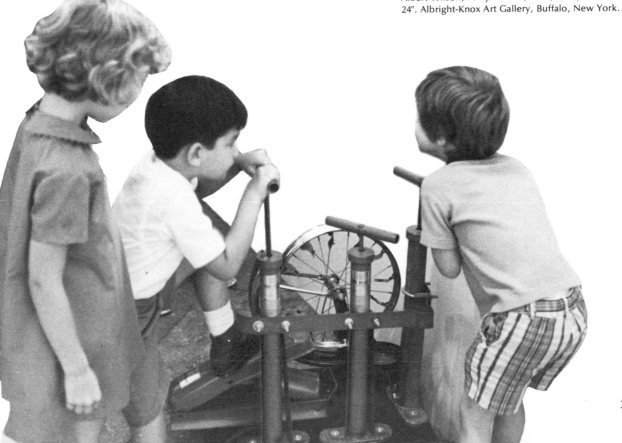

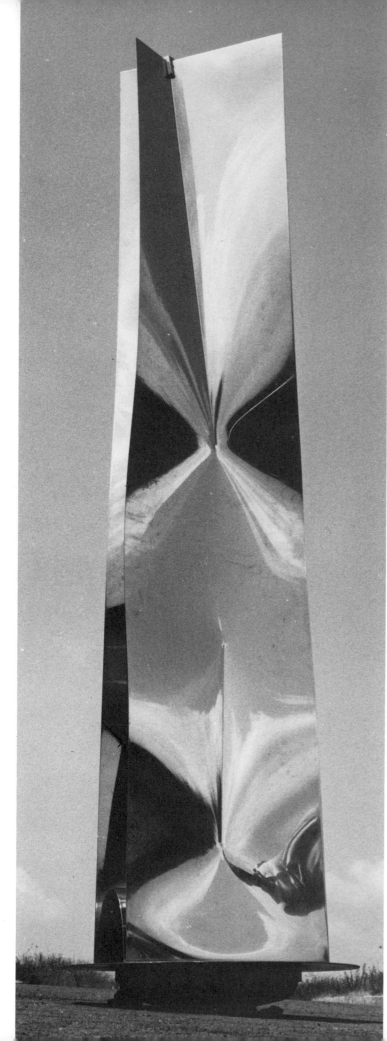

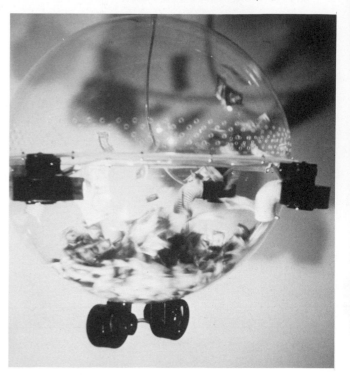

Attilio Pierelli, *Saturno I*, stainless steel, Zabriskie Gallery, New York.

John Harris, *Cash Flow*, Plexiglas, electric fans, dollars, diameter 40". Howard Wise Gallery, New York. (Photograph by Susan Hopmans)

John Harris, *Cash Flow*, (close view). (Photograph by Susan Hopmans)

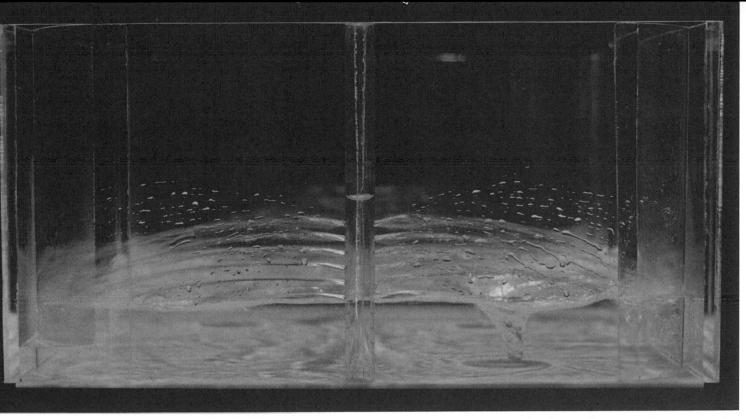

Rachel bas-Cohain, *Study I for Grand Vortices*, 1971, water, recycling pump, Lucite box, 24" × 24" × 12". Courtesy of the artist.

Rachel bas-Cohain, *Study I for Grand Vortices,* detail.

Rachel bas-Cohain, *Ribbons of Bubbles* ⅜", 1970, soapy water, pumped air, Plexiglas, 36" x 48" x ¾". Owned by Princeton University. Courtesy of the artist.

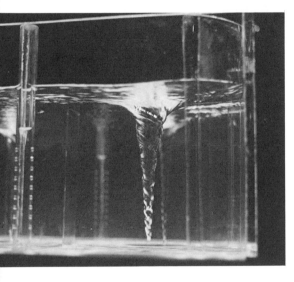

WATER SCULPTURES

The movement of water has captured the imagination of modern sculptors for its possibilities as a kinetic art medium. Rachel bas-Cohain's water sculptures create patterns of motion in the flow of water. The *Study I for Grand Vortices* uses water in a Lucite container with a recycling pump. As the water rises, moving vortices appear like sculptural forms in the clear plastic box. In *Ribbons of Bubbles* ⅜" the space between two Plexiglas sheets is filled with soapy water. An air pump moves the bubbly liquid, creating changing patterns.

31

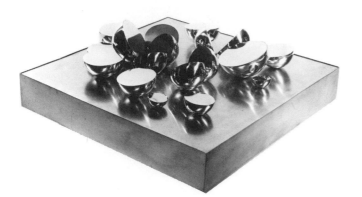

Pol Bury, *Dix-sept demi sphères sur un plateau* ²/₈, copper, 25″ × 50″ × 50″. Lefebre Gallery, New York. (Photograph by Serge Béguier)

SCULPTURES THAT MOVE MYSTERIOUSLY

While some kinetic sculptures show the structure of their movement, Pol Bury's sculptures appear to be controlled by an invisible power. Their hidden motors create slow and mysterious movements of the sculptural forms. In *Dix-sept demi sphères sur un plateau 2/8* the metal geometric shapes move unexpectedly and at random. In *Ball on Cube* a large sphere slowly rolls around the top surface of the cube but never falls off; it

Pol Bury, *Sphère en 4 parties sur cylindre*, 1972, stainless steel, 20′ × 4½″. Lefebre Gallery, New York. (Photograph by O. E. Nelson)

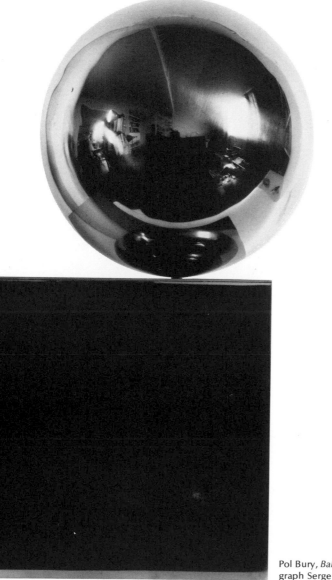

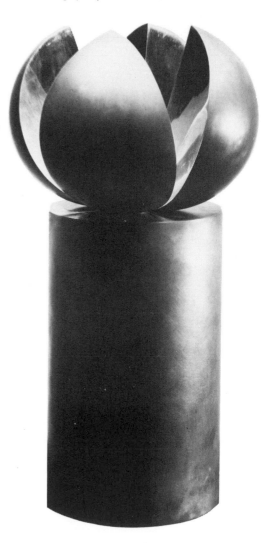

Pol Bury, *Ball on Cube*, stainless steel. Lefebre Gallery, New York. (Photograph Serge Béguier)

appears to defy gravity and creates a sensation of suspense. A steel sphere on a cylinder opens and closes like a flower. *Sphère en 4 parties sur cylindre* is a sculpture that uses modern materials yet reminds us of nature and its processes of growth.

Movement takes place in open space in the sculpture of Takis Vassilakis. Some parts of the sculpture are suspended and appear to float; these forms seem to be controlled by invisible forces but are really operating under the simple principle of magnetism. In *Tele-Sculpture* the black cork and white wooden sphere have magnets in them. Takis keeps these forms in constant motion through the use of an alternating electromagnetic field.

The *Three-Dimensional Module* sculptures of Adrianne Wortzel are a series of geometric forms. They have planned movements which change as the lever motor moves the forms up and down. They appear to breathe and have a life of their own. Each part is related to another, and the sculpture is designed to move in all directions.

Adrianne Wortzel, *Three-Dimensional Module*, scored and die-cut cardboard, lever motor, width 24″, depth 24″, pyramids 4″. Courtesy of the artist.

Takis Vassilakis, *Tele-Sculpture*, 1960–62. Three part construction: an electromagnet, height 10⅜″, diameter 12⅝″; a top-shaped black-painted cork, height 4″, diameter 1¾″; a white-painted wood sphere, diameter 4″, the latter two containing magnets. Collection, The Museum of Modern Art, New York. Gift of Dominique and John de Menil.

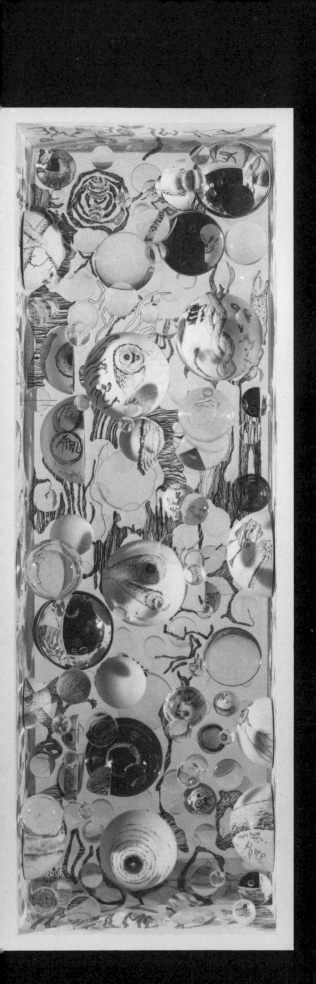

OPTICAL SCULPTURES

The drawing in the *Half Tree* sculpture of Mary Bauermeister is distorted and multiplied by the use of layers of optical lenses. The viewer is intrigued by the changing quality of the sculpture, which gives the illusion of movement.

Looking through the fascinating *Magiscopes* of Feliciano Béjar, the viewer is transported to a world of multiple images and bending shapes. In these sculptures, which evolved during eight years of experimentation, the artist uses metal, mirrors, glass, and plastic lenses.

SCULPTURES THAT VIBRATE

An oversize cube of Jello wiggles and waggles, an inedible reminder of a familiar dessert. Roger Vilder's sculpture *Jello,* a vibrating cube made of silicone, is set into action with a motor that activates springs.

Mary Bauermeister, *Half Tree,* 1965. Galeria Bonino, New York. Collection of Larry Aldrich. (Photograph by Peter Moore)

Feliciano Béjar, *Lens Box (Magiscope),* 1970, plastic and mirrors. Bertha Schaefer Gallery, New York.

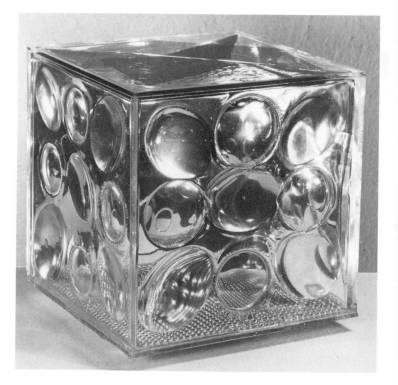

Feliciano Béjar, *The Acrobats and The Gazebo, (Magiscope),* crystal and metal. Bertha Schaefer Gallery, New York.

Roger Vilder, *Jello,* 1969, silicone, 24" x 24" x 18". The Electric Gallery, Toronto, Canada.

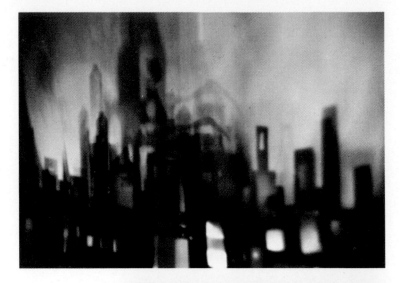

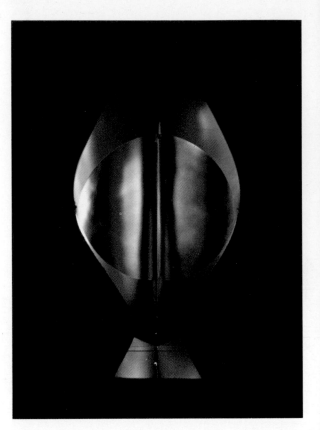

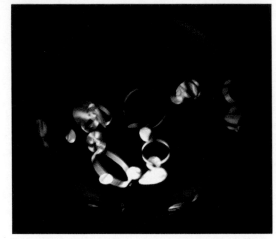

Adam Peiperl, Origin, *1971, polarizing light, motor, and plastic* (Marlborough-Gerson Gallery, New York)

Adam Peiperl, Astralite 3, 1972, colorless transparent strained plastic, liquid-filled glass, sphere, polarized light, propeller, and motor. (Marlborough-Gerson Gallery, New York)

William Accorsi, Uncle Sam (two views), 1971, pine wood, white glue, collage, and paint.

Robert Sullins, Shooting Gallery St. Sebastian, 36" × 48" × 6". Courtesy of the artist.

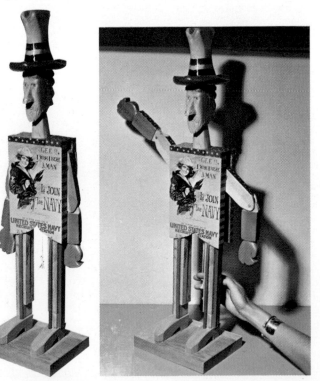

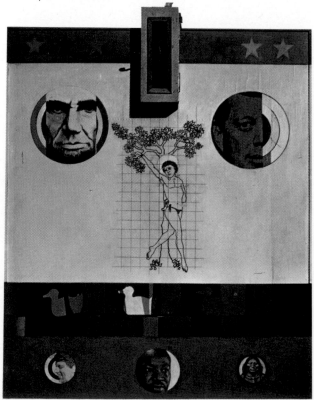

SCULPTURES THAT REACT TO CLIMATE

A steel sculpture curls and uncurls itself as the temperature changes from cold to warm. Tony Fugate Wilcox's *Temperature Strip I,* made of steel and nickel, reacts to the environmental conditions around it. His sculpture *Iron and Carbon* is designed to change over a period of approximately three thousand years. The two materials will undergo chemical change and eventually diffuse. Depending on size, some of these sculptures are fabricated in machine shops under the supervision of the artist.

The climate in the area of display is a factor which affects the appearance of Hans Haacke's *Condensation Cube.* The natural cycle of condensation, whereby vapor is converted to liquid, becomes the ever-changing material in this sculpture. Hans Haacke has done extensive work with sculpture that interacts with the environment. In his sculpture *Ice Table* (see page 16), he uses a refrigeration unit which condenses and freezes moisture from the surrounding air. This results in a layer of frost on the sculpture, which alternately builds and melts as temperature conditions vary.

PARTICIPATORY SCULPTURES

The viewer is needed to pull the cord and put William Accorsi's caricature figure of *Uncle Sam* (see opposite) into action; a simple pull-cord mechanism is attached to both arms of the sculpture.

The ducks move, as in a real shooting gallery, in *The Shooting Gallery St. Sabastian* (see opposite) by Robert Sullins. There is a pop gun which the spectator can load with corks and shoot. In this participatory sculpture, the artist also makes a bitter social statement about American society.

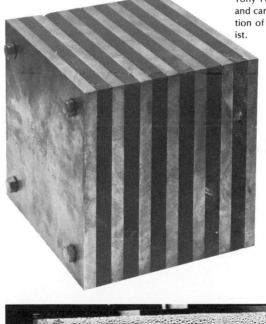

Tony Fugate Wilcox, *Iron and Carbon,* iron and carbon, 12″ x 12″, weight 120 lbs. Collection of Marc Blondeau. Courtesy of the artist.

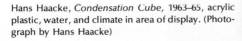

Tony Fugate Wilcox, *Temperature Strip I,* invar steel and nickel, 70′. Courtesy of the artist.

Hans Haacke, *Condensation Cube,* 1963–65, acrylic plastic, water, and climate in area of display. (Photograph by Hans Haacke)

A student explores the possibilities of liquid crystals encapsulated in plastic. These react to temperature by changing color.

Laser Room, 1972, lasers and mirrors, a student group sculpture at State University at Stony Brook. Experimentation with laser technology is part of the school's art curriculum. Courtesy of Lewis Lusardi.

Electric Floor, 1972, using circuits, is another student group sculpture at State University at Stony Brook. As the viewer walks on this floor sculpture he can create a musical tune. Courtesy of Lewis Lusardi.

Music Dome, 1972, a student group sculpture at State University. This sculpture lights up in response to sound. Courtesy of Lewis Lusardi.

chapter 4
Kinetic Art and Today's School

WHY?

Because our world vibrates with electronic music, jet planes, speeding cars, television, and flashing billboards. Because art expression must reflect the world in which we live. Because the young artist must express himself with the materials of his time. Because the traditional approaches to sculpture, while important to experience, are not enough. Because the young artist must be open-minded to the directions of today's sculpture. Because new materials present a challenge to the young artist's imagination.

THE CHALLENGE

It is our strong belief that every art program should reflect the world in which we live. The opportunities for adventure and discovery with today's art and materials are endless. It was this conviction that led us to the challenge of kinetic sculpture.

As we explored new directions, we realized that our roles as teachers were changing. The extraordinary diversity of kinetic sculpture required constant experimentation and flexibility. There were no stock methods for producing a successful kinetic sculpture. Science offered many possibilities for creative sculpture, but use of these possibilities had to be viewed as a means and not as an end in itself. The teacher-student relationship took on a new dimension as both searched for answers to technical problems. We are convinced that the process involved in creating a kinetic sculpture has great value for our students.

Kinetic sculptures by students at West Hempstead High School. (Photograph by Fortune Monte)

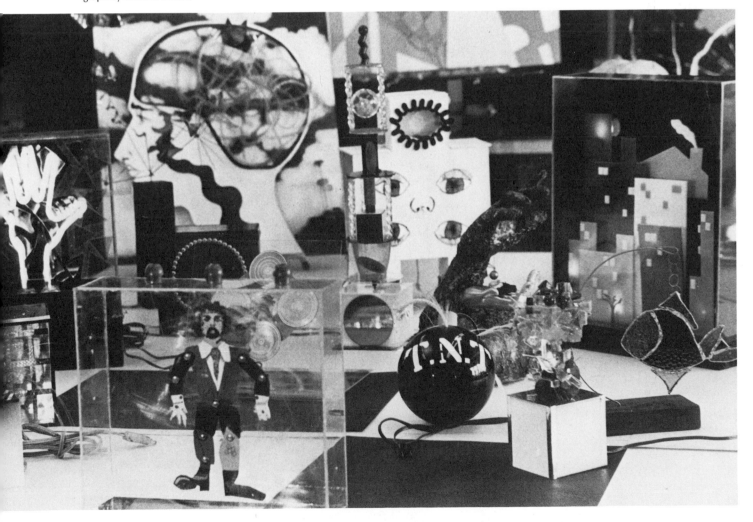

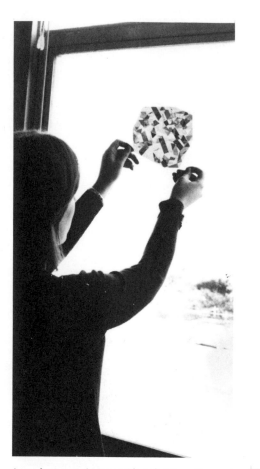

A student experiments with polarizing filter and Scotch tape, to see the effects of movement and light.

Students at work.

MEETING THE CHALLENGE

Some students had concepts for sculptures which were beyond their technical ability. It did not take long to recognize that our knowledge in areas such as physics, chemistry, mechanics, and electricity was limited.

"Will this work?" was a common question raised by young artists working on their sculptures. When a problem arose, our approach was to encourage everyone to contribute whatever information he had. We were constantly alternating roles; students with specialized skills became teachers, while we, as teachers, enjoyed learning along with the rest of the group. As the need arose, capable students gave demonstrations in such areas as wiring, connecting a water pump, or repairing a motor. We tried to create a "think-tank" atmosphere in the classroom, where all ideas were worthy of consideration.

Having a positive attitude was important. When we worked in unexplored areas, we found that frustrations did occur. We accepted these as a normal part of the creative process. Our function as teachers was to present alternatives, so that our students could think their problems through. It was a beautiful experience to be there when concepts suddenly became realities and everything fell into place. This, after all, is what the creative process is all about.

THE ART STUDIO

The classroom environment where young artists work should convey the excitement of art. A dynamic studio motivates activity and invites participation. Displays of student work, new books, magazines, and prints of professional artwork make the art studio come alive. Articles about current developments in art, found in local papers and magazines, are extremely valuable. Students enjoy finding and discussing these articles, which bring the art world closer to the classroom.

Early in the year, we encouraged students to bring in interesting mechanical devices and other materials which could be useful in creating kinetic sculpture. We displayed the more interesting objects such as musical instruments, music boxes, sound devices, and motors. To avoid boredom the displays were constantly changed. A good resource file was organized, using the materials from the bulletin board.

It is the art teacher who sets the tone in any art studio. His awareness and enthusiasm are evident the moment one enters the classroom. There should be more than enough to look at, touch, and do. This should be the unique place that encourages a new way of thinking and seeing.

A student cuts plastic with an electric portable saw. The plastic will be used in a light sculpture. (Photograph by Fortune Monte)

A student incises designs on plastic with a woodcutting tool. (Photograph by Fortune Monte)

Students work together heating and bending plastic for a light sculpture. (Photograph by Fortune Monte)

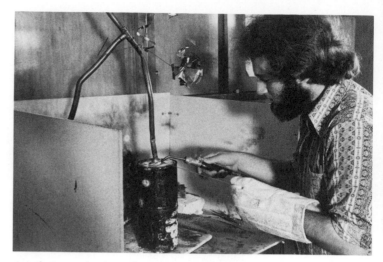

A student uses a brazing technique to join metals for a kinetic sculpture. (Photograph by Fortune Monte)

WORKING AS A TEAM

Team teaching is an ideal situation for teaching kinetic sculpture and this situation exists in some schools. Science and art teachers in the same classroom can become partners in developing the creative process.

At C. W. Post College in Long Island, New York, a chemistry laboratory has become the studio for a kinetic-sculpture class. Professor Stephen Soreff, an artist, and Professor James M. Dwyer, a physicist, jointly teach the sculpture students. Together, they help students to solve both aesthetic and technical problems, as they arise.

Groups of students can work together in kinetic sculptures, sharing problems and contributing solutions as a team. At State University of New York at Stony Brook, students of Professor Lewis Lusardi experiment with kinetic sculptures using lasers, polarized light, crystals, fiber optics, electric, and electronic systems. Several students at this school created a *Laser Room* (see page 38), using the unique qualities of laser beams as part of a sculptural environment. Laser beams remain concentrated and brilliant when projected. In this room, ten large mirrors bounce the laser images back and forth.

Electric Floor (see page 38) is another group sculpture by Lusardi's students.

By walking on this sculpture, which generates three octaves of musical notes, the spectator can create a musical composition. When sound is fed into the *Music Dome* (see page 38), a geodesic dome which is programmed to respond to five different sound frequencies, the dome reacts by lighting up.

At Hofstra University in Long Island, a huge, inflatable sculpture was designed by Dianne Della Rocco, a student of Professor David Jacobs. This polyethylene sculpture was sewn together by several students at the university. It was then inflated by using electric fans and finally became an environmental sculpture for a musical presentation.

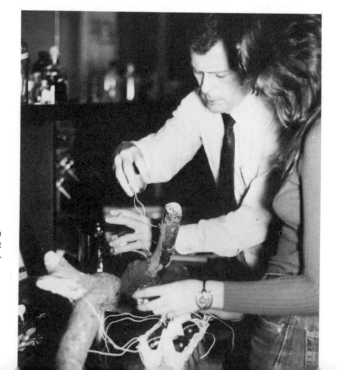

A science professor gives technical assistance to an art student in the Sculpture and Chemistry class at C. W. Post College in Long Island. This class is conducted in a chemistry laboratory.

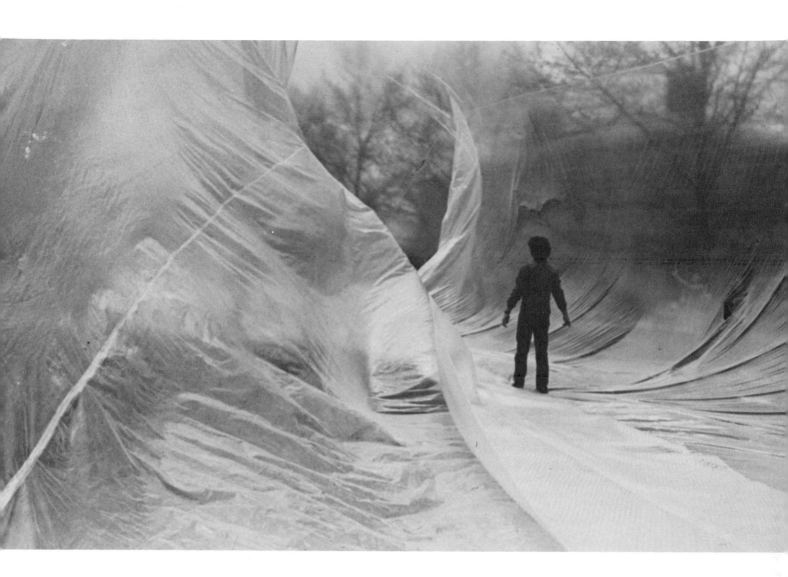

Above and right:
Dianne Della Rocco, *Inflated Structure,* Hofstra University, New York, polyethylene, length 100'. This huge inflated sculptural form was the environment for a musical presentation by Hofstra students. It was first sewn together, then inflated with fans and tethered with nylon cord. (Photograph by Hoot Von Zitsewitz)

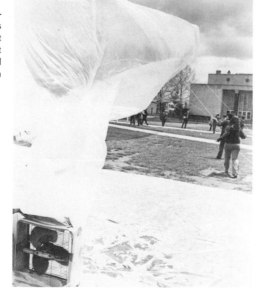

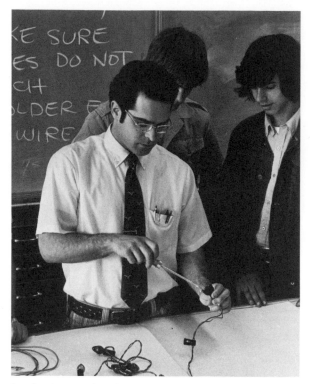

An electricity teacher demonstrates wiring techniques for sculpture students. (Photograph by Fortune Monte)

The school custodian demonstrates glass-cutting techniques. (Photograph by Fortune Monte)

David Jacobs, *Wah Wah* at Herricks High, New York, 1971. Fine aluminum pipes at the end of this sculpture emit varied sounds. Courtesy of the artist.

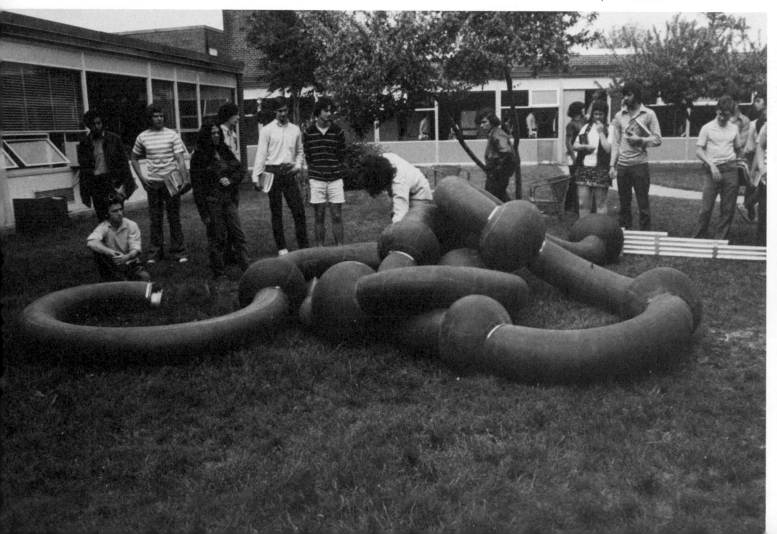

THE EXPANDING CLASSROOM

There are many sources for technical help beyond the classroom. Science and industrial arts teachers can answer many student questions. Students should also feel free to consult with parents, friends, and others knowledgeable in the areas of chemistry, electricity, carpentry, plumbing, and engineering. People are usually eager to help and they are proud to see their efforts become part of a successful work of art. Just as professional sculptors have turned to engineers, scientists, and people in industry for assistance, so must teachers seek solutions outside their classroom.

Open your classroom and invite guests to give mini-lessons. Exciting demonstrations can be given in electric wiring, various types of motors and their use, crystal growing, properties of magnets, or polarized light. Methods of working with plastics, wood, glass, and joining techniques such as soldering, brazing, the use of liquid acrylic and epoxy cement, are other possibilities for demonstrations by the teacher or guests.

Students are often inspired by watching a professional sculptor at work. At Herricks High School in New York, art students had the unique experience of assembling an inflatable, sound-producing *Wah-Wah* sculpture with artist David Jacobs.

West Hempstead High School sculpture students visited sculptors Tony Fugate Wilcox and Elliott Barowitz in their studios in New York City. They gained a greater understanding of artists as people, their motivations, and the ways in which they work.

WAYS TO BEGIN

Take a trip to a museum or gallery to see artwork produced by professional kinetic sculptors. Invite a local sculptor to talk about his work or arrange to have students visit his studio. Show slides, filmstrips, and movies on kinetic art (see page 78); refer to newspaper and magazine articles about current happenings in sculpture.

Explore sources in your area for the unconventional supplies needed for kinetic sculpture; an unusual material can at times be the motivation for a sculpture. One of the first places to look is through discarded parts of electrical and mechanical objects. Moving window and store displays can often be obtained for the asking. Stores selling electric and electronic equipment, motors, pumps, hardware, hobby materials, and assorted surplus items can be found in most local areas. Manufacturers may have surplus products which they are willing to contribute to schools. Toy parts, gears, sound devices, rubber tubing, metals, and plastics are some of the possibilities which can be explored.

Many scientific materials can be the inspiration for kinetic sculpture and it is a good idea to explore some of the following: black and strobe lights, different types of chemical crystals, diffraction grating, fiber optics, Fresnel lenses, magnetic materials, moiré patterns, multi-lensed plastic sheeting, optical lenses, polarizing materials, and prisms.

Specialized catalogs and magazines list sources for materials unobtainable elsewhere. The widest selection of supplies for kinetic sculpture was found at Edmund Scientific Company. Before beginning any work, send for their catalog, which is well illustrated and explains the materials clearly. Other sources are *Popular Mechanics* and *Popular Science* magazines and *Playthings,* a directory for toy manufacturers (see Sources of Supplies for addresses).

Students look for unusual materials in the surplus stores of the SoHo district in New York City.

A visit to the Greenwich Village studio of Elliot Barowitz helps students understand how the artist works.

Artist Tony Fugate Wilcox discusses his kinetic sculptures with students at his studio in the SoHo district of New York City.

part two
DESIGNING YOUR OWN KINETIC SCULPTURE

All sculptures shown in this section of the book are the work of our students at West Hempstead High School. They were created by both beginning and advanced sculpture students. By presenting examples of individual work, we hope to give a clear and understandable description of the construction of kinetic sculptures. Our students' experiences show the development of their original concept, as well as the problems they encountered. These summaries are not intended to serve as plans; rather, they should make the reader aware of the wide range of solutions possible with the use of the fascinating materials available today.

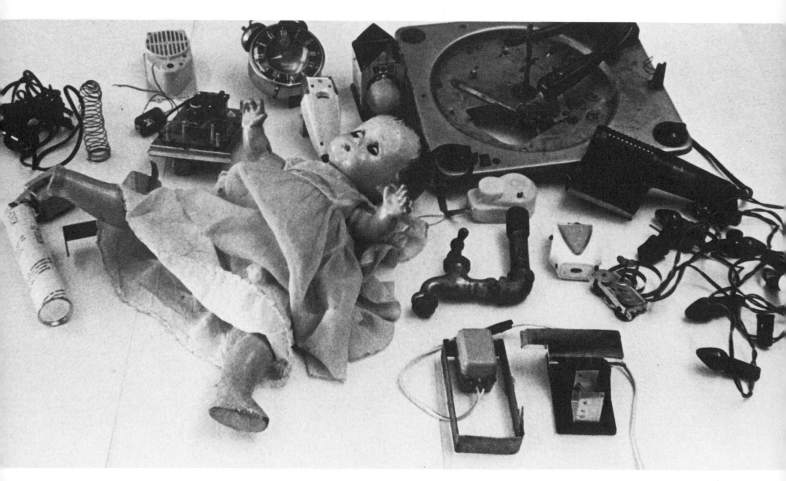

An array of discarded materials collected by the students for use in their kinetic sculptures. (Photograph by Fortune Monte)

Repeating-Image Light Box. *(Photograph Fortune by Monte)*

Neon Hand. *(Photograph by Fortune Monte)*

Reflecting and Distorting Light. *(Photograph by Fortune Monte)*

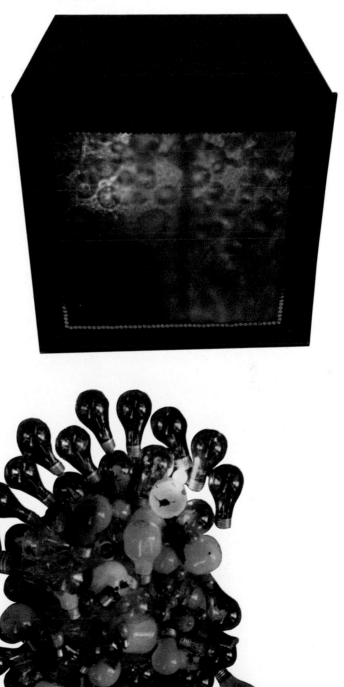

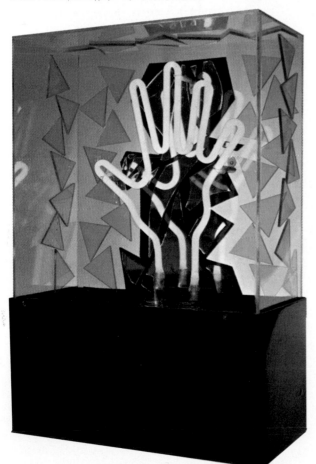

Blinking Light and Light Bulbs. *A collection of discarded and broken light bulbs of all sizes and shapes was the material for this sculpture. Blinking lights were added to create the feeling of movement to the sculpture.*

chapter 5
Electrical Approaches

LIGHT SCULPTURES

Light in kinetic sculpture offers great flexibility and variety. As light is emitted from a source, it can simply provide illumination for a sculpture. With the addition of optical devices, the artist can control light to create various effects. Light can be reflected or projected. It can be programmed to blink on and off. It can be piped through transparent acrylic sheeting or tubing, to emerge at the edges. Light can be broken or diffracted into rainbow colors by using a prism or diffraction grating. With Fresnel lenses, light can be refracted or bent, thereby distorting images. Polarizing filters cause light to vibrate in one direction only and can be used in many ways. One possibility is to use these filters to make certain stationary transparent materials (such as clear tape or cellophane) appear to move.

Sometimes, in kinetic sculpture, the light source is hidden and appears in changing patterns on a screen. At other times, the light source itself is the art material for the sculpture.

Many different types of lights are available for use in kinetic sculpture. They can be obtained from the following sources: old lamps, fixtures, Christmas tree lights, discarded store and window displays, electric and electronic supply stores, hardware stores, neon sign companies, and surplus stores.

To begin, gather the available materials. Decide how your kinetic sculpture will use light and what effects you would like to have. Do you want to amuse, mystify, or startle the spectator? Will prisms produce rainbows of color? Have you thought about using mirrors to create endless reflections or distortions? Will you give new form to light by designing with neon tubing? Have you considered transmitting light through clear plastic or fiber optics? Will your sculpture become a "light painting" viewed on a screen? Does your plan include the use of polarizing materials in combination with light? Will your light rays be stationary or moving — will they flash on and off? Have you thought about whether your sculpture will be viewed in a darkened room or in daylight?

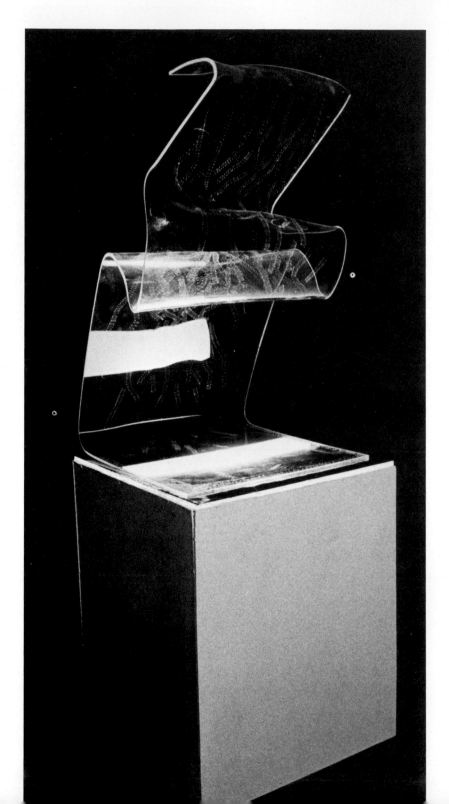

Edge Lighting Incised. Light is piped through transparent plastic to emerge at the incised lines and at the edges. (Photograph by Fortune Monte)

Light and Music. *Carefully arranged plastic shapes in spectral colors glow in white light. A music box was added to create an audio-visual effect. (Photograph by Fortune Monte)*

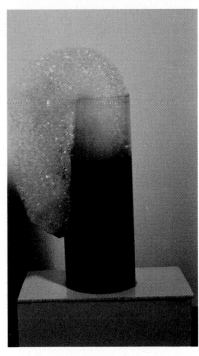

Aquarium Pump With Bubbles.

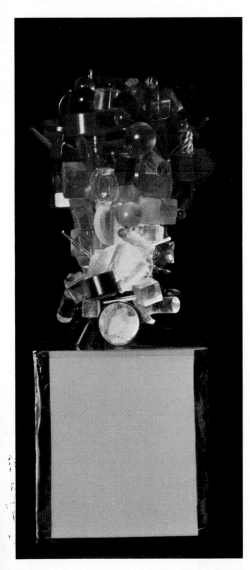

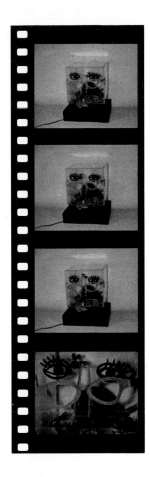

Plastic Head With Bee. *In this amusing sculpture a bee is held by a slowly revolving motor obtained from a rotisserie.*

Winchester Cathedral. *This traditional scene in modern materials is accompanied by a rock tune. Colored and clear plastic are combined with lights and a mechanical music box. (Photograph by Fortune Monte)*

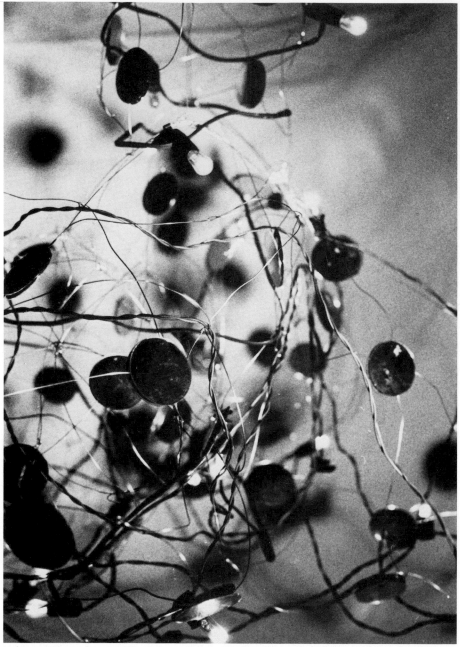

Lights and Mirrors. Tiny twinkling lights are reflected in an airy structure of mirrors and wire.

REPEATING-IMAGE LIGHT BOX

An exciting environment filled with flashing lights and multiple images is created by this sculpture (see page 47). Controlled changes occur from within the sculpture as light is broken up and reflected.

Masonite
epoxy cement
plastic repeating-image lenses (negative Fresnel)
diffraction art foil
blinking white and colored Christmas lights
electric saw
aluminum foil
black plastic tape
drill
black spray paint

This sculpture began with a desire to work with light as the art material. Blinking Christmas lights were the available material for the source of light. The parts of the sculpture were cut out of Masonite and holes were drilled in the back piece to provide for air circulation. An opening was cut in a bottom corner to accommodate the cord and plug. The lights were attached to the back of the box and it was then cemented together. Finally, the entire box was sprayed black, with care taken to protect the lights inside.

Experimentation took place with various reflecting materials such as mirrors, self-adhesive Mylar, and diffraction art foil. Diffraction foil was chosen as the most effective material. A screen was needed on the front of the box; this would allow the light to come through and also heighten its effect. A plastic repeating-image lens was decided upon and was attached with black plastic tape.

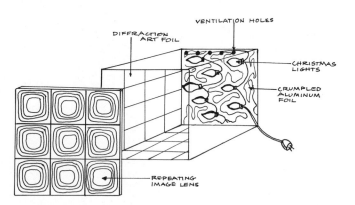

Diagram showing construction of *Repeating-Image Light Box.*

REFLECTING AND DISTORTING LIGHT

Light is bent, stretched, and distorted as the viewer watches this fascinating luminous sculpture (see page 47). Colors and forms appear to dance as they slowly move back and forth on a translucent plastic screen. This surface acts as a light-diffusing rear projection screen. The constantly moving images are projected on to it from the boxed-in mechanism.

multi-lensed thermoplastic sheeting (.0075 in. thick)
Mylar film
rotating motor
cardboard
colored cellophane
spotlight
Masonite
black paint
aluminum foil
epoxy cement
patterned plastic sheeting
drill
electric saw

The effects of strong light on irregular shiny surfaces were the basis for this sculpture. A distorted Mylar film disc, mounted on cardboard, was attached to a rotating motor. The Mylar film was bent and heated with a direct flame to create the irregularities. This mirrored Mylar disc and a motor were attached to the back of a Masonite box. A screen for the front of the box was made of multi-lensed thermoplastic sheeting, and was joined to a Masonite frame. Various materials such as Mylar, aluminum foil, mirrors, colored cellophane, and patterned plastic sheeting were tested for their effects on the front screen. When the desired combination of movement, color, and light was obtained, the mechanism was enclosed.

NEON HAND

This purple neon hand glows eerily in a darkened room (see page 47). It is in a transparent plastic box filled with colored shapes. All the electrical devices, except for the glass tubing, are hidden in a metal base.

colored and clear acrylic sheeting
liquid acrylic cement (ethylene dichloride)
transformer
neon tubing fabricated to artist's design
metal for base

The fascinating possibilities of neon motivated this student to seek out a sign-maker for fabrication of her design. She first designed the entire sculpture and decided on the part to be crafted in neon. She then made an exact-size drawing of the hand and consulted with local sign-makers about the cost and production. While the hand section was being fabricated, she constructed a plastic environment to enclose it. A black metal base was designed to house the transformer.

POLARIZED LIGHT

Strange happenings take place when the viewer rotates a knob on the front of this sculpture which makes use of polarized light. Colors change and lines move when light is introduced behind two polarizing filters.

plastic polarizing material
cellophane tape
white indoor Christmas tree lights
Masonite
epoxy cement
wooden beads
aluminum foil
scrap wood
black paint
electric saw
drill
straight pin

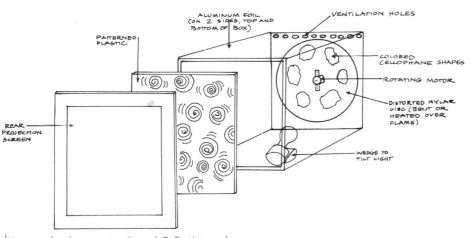

PATTERNED PLASTIC
ALUMINUM FOIL (ON 2 SIDES, TOP AND BOTTOM OF BOX)
VENTILATION HOLES
COLORED CELLOPHANE SHAPES
ROTATING MOTOR
DISTORTED MYLAR DISC (BENT OR HEATED OVER FLAME)
REAR PROJECTION SCREEN
WEDGE TO TILT LIGHT

Diagram showing construction of *Reflecting and Distorting Light.*

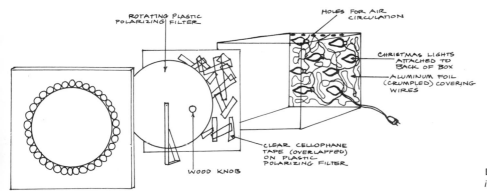

ROTATING PLASTIC POLARIZING FILTER
HOLES FOR AIR CIRCULATION
CHRISTMAS LIGHTS ATTACHED TO BACK OF BOX
ALUMINUM FOIL (CRUMPLED) COVERING WIRES
CLEAR CELLOPHANE TAPE (OVERLAPPED) ON PLASTIC POLARIZING FILTER
WOOD KNOB

Diagram showing construction of *Changing Patterns in Polarized Light.*

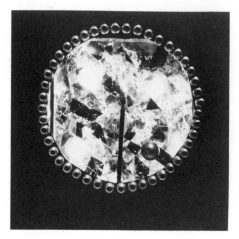

Student work, *Changing Patterns in Polarized Light.*
(Photograph by Fortune Monte)

Fiber Optics. (Photograph by Fortune Monte)

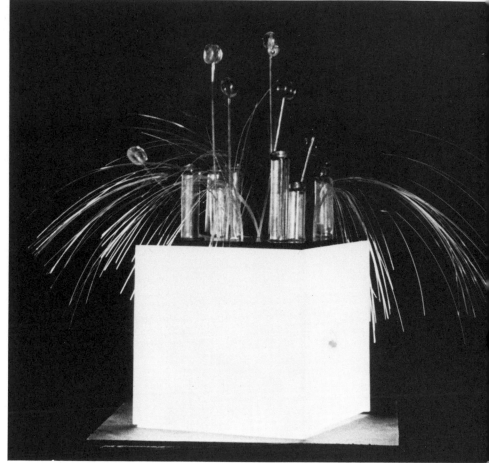

The idea for this sculpture came from experimentation with two pieces of polarizing filter material and clear cellophane tape. Clear tape has the property of changing the direction of polarization. On one piece of polarizing material a design was created by overlapping the tape. When the second filter was rotated in front of the stationary design — and held up to the light — changing patterns occurred. A Masonite box with a round opening was prepared. White Christmas tree lights were installed on the back wall of the box. Aluminum foil was placed behind the lights to increase reflection and to conceal the wires. The front filter was mounted so it revolved like a pinwheel. This was placed just behind the opening of the box. The polarizing filter with the clear tape design was secured — facing the box opening — in front of the lights. Caution had to be taken not to place the plastic filter too close to the light source, since heat might warp it. Holes were drilled to provide for ventilation. The entire box was painted black and decorated with silver wooden beads.

FIBER OPTICS

In this sculpture, brilliant points of light glow at the tips of long plastic tubes; here, the source of illumination is hidden. Numerous fiber optic strands, placed near the source of light, carry this light to their ends. With this technique light can be piped, like liquid, to any location.

 plastic fiber optic strands
 opaque and translucent white acrylic
 sheeting
 glass pebbles
 epoxy cement
 electric light
 plastic rods
 electric saw
 drill

The fascinating properties of fiber optics were the motivation for this sculpture. A plastic base was constructed to conceal the light source. It was made of four opaque sides and a translucent top with holes drilled into it. The parts of the base were joined with epoxy and the light was secured inside. The numerous plastic fiber optic strands were inserted through the holes, directed to the light, and glued into place. Some of the holes in the top surface were left open for circulation of air. Other plastic rods and colored glass pebbles were added to create the total effect.

EDGE LIGHTING

This transparent plastic sculpture uses the principle of edge lighting. Light enters, and is trapped and transmitted through the curved plastic shape. It appears again, glowing on the edges and incised lines of the sculpture. This gives the feeling of lines of light suspended in space.

 carving tools
 drill
 Masonite
 clear and translucent acrylic sheeting
 heat for bending plastic (torch, burner, or oven)
 liquid acrylic cement (ethylene dichloride)
 nails
 wood for shelf
 electric saw
 epoxy cement
 black enamel paint

Designs were incised on a rectangular piece of clear plastic with woodcutting tools. Asbestos gloves were worn while bending the plastic over an open flame. It is important that the flame be kept at a distance from the plastic since too much heat will mar the surface. Approximately 250°F. is all that is needed to soften plastic; the entire process takes only a few minutes. The base was then constructed, with a shelf to hold the light source. To avoid overheating, a row of holes was drilled in the back of the base. The top of the base was made of translucent plastic. The space surrounding the base of the sculptural form was painted black to intensify the light source. The sculpture was then attached to the base with liquid acrylic cement.

BLINKING LIGHTS AND REFLECTIONS

A tall honeycomb structure twinkles with numerous colored lights — they blink on and off at random. The many mirrored surfaces reflect and multiply the lights. The shiny styrene plastic form used in this sculpture — purchased in a surplus supply store without any concept of its real function — became a sculptural material.

 styrene plastic found object
 wood
 blinking Christmas tree lights
 self-adhesive Mylar
 epoxy cement
 wood-carving tool

Three pieces of honeycomb plastic were joined together into a triangular form. Blinking Christmas lights were inserted into the small openings throughout the sculpture. A groove was carved in the solid wood base to accommodate and conceal the electric wire. The entire structure was then cemented to the Mylar-covered base. The result was an effective sculpture which used a manufactured material in a new way.

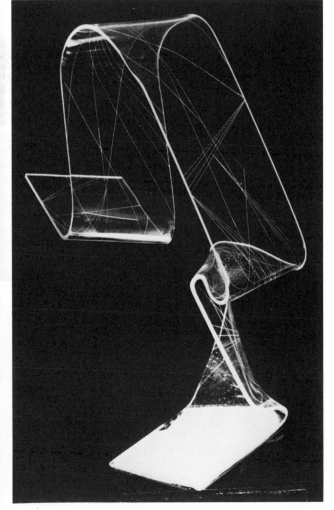

Edge Lighting. (Photograph by Fortune Monte)

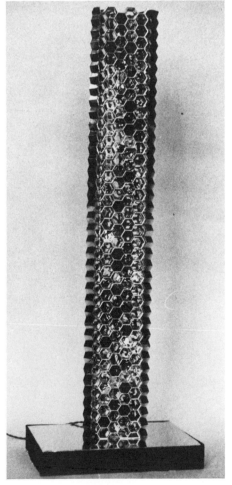

Blinking Lights and Reflections.

MOTION SCULPTURES

Rotating and vibrating motors are available in varying speeds. They may be battery driven or they may use alternating current from an electrical outlet. Working motors may be obtained from the following sources: discarded store and window displays, old phonographs, shavers, vacuum cleaners, rotisseries, hair dryers, dishwashers, fans, washing machines, toys, clocks and other appliances, surplus or thrift stores, electric and electronic supply stores, and hobby shops.

To begin, analyze the available motor. How fast does it move? Will your sculpture change character as it turns? How will the parts of your sculpture interact with each other? Will the movement of the motor be a mystery to the viewer, or will it be visible? Will you use a reflective surface so that light becomes a part of your design? What effects will your sculpture have on the viewer?

Plastic Tower. The multi-colored discs with moiré patterns change as they slowly revolve in this sculpture. (Photograph by Fortune Monte)

Variation in Space (two views). Tongue depressors were used to create this graceful construction which is turned by a slow-revolution motor.

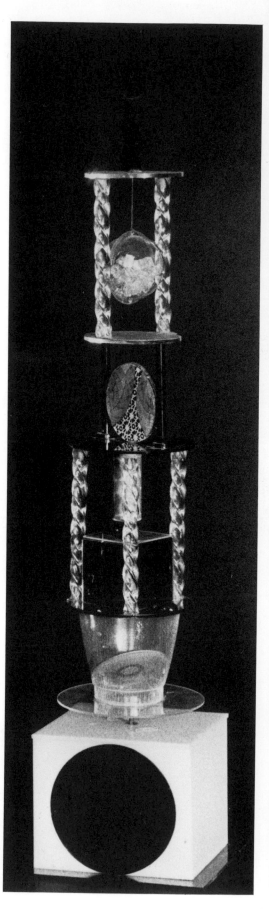

Motor and Magnets. Metal shapes are moved by a hidden magnet.

Motor and Magnets (Close up of movement).

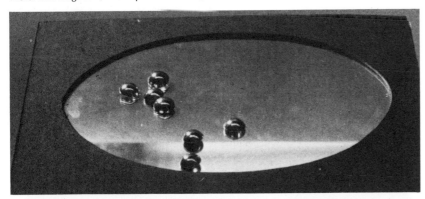

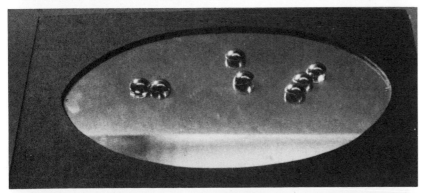

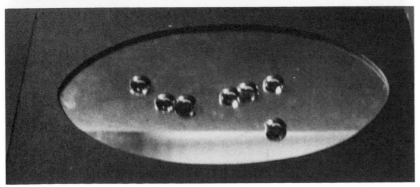

MOTOR AND MAGNETS

This is a sculpture that constantly changes and involves the viewer with its movement. The use of magnets creates action that is irregular but constant. The shapes appear to move mysteriously — as if controlled by invisible forces.

 rotating motor
 mirror
 Masonite
 two magnets
 upholstery tacks
 self-adhesive Mylar
 black cardboard
 electric saw
 epoxy cement

This sculpture began with a rotating motor obtained from a window display. After the final sculpture was visualized, a Masonite box was constructed to enclose the motor. Two magnets from a kitchen bulletin board were attached to both ends of a bar, mounted on the rotating motor. The magnets were first tested to see if they were powerful enough to move a metal object on the other side of a mirror. After this proved successful, the sculpture was continued to completion. For a unified effect the sides were covered with self-adhesive Mylar, which created reflections and added to the illusion of movement.

MOTOR, LIGHT, AND MIRRORS

The reflecting qualities of mirrors and Mylar — in combination with light — play an important part in this sculpture. As the viewer moves in closer to the polished surfaces, he sees the ever-changing image of his face. He becomes part of the flickering movement. The motor is hidden so as not to detract from the rotating plastic and mirrored forms.

 rotating motor with light socket (from
 discarded window display)
 epoxy cement
 plastic rods
 ⅛ in. Masonite
 liquid acrylic cement
 self-adhesive Mylar
 small nails
 scrap wood blocks for reinforcement
 electric saw
 matte black spray paint
 epoxy cement
 small round mirrors
 clear acrylic sheeting

Since a rotating sculpture must work from all directions, this sculpture was constructed in the round on a plastic base. Small mirrors and plastic rods were joined with epoxy cement. Liquid acrylic cement was used when it was necessary to bind two plastic surfaces to each other.

To provide a reflecting environment for this rotating sculpture, a sturdy Masonite box with a front opening was constructed. A curved Mylar backdrop was placed behind the sculpture. The motor and light were placed in the base of the box behind a strip of Masonite. The exterior of the box was sprayed matte black so as not to detract from the reflections, while all interior surfaces were lined with Mylar.

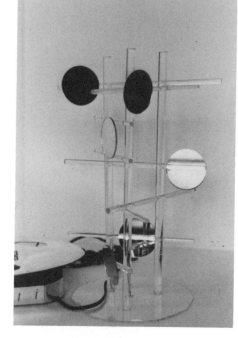

Motor, Light, and Mirrors. The sculptural form and the motor before they were assembled.

Motor, Light and Mirrors, as a finished sculpture.

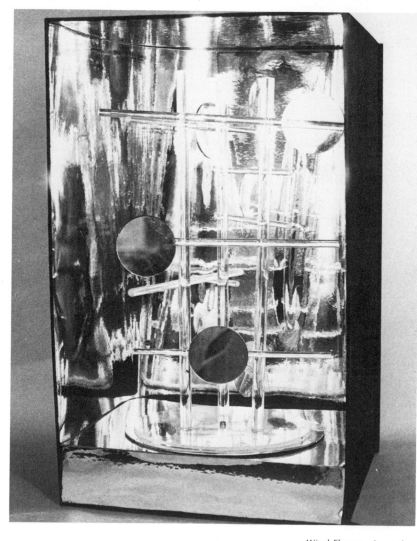

Crisscross Rows. A slowly revolving dowel, with imbedded wire rods, meshes with rows of colored wool. (Photograph by Fortune Monte)

Moiré Movement. A moiré disc attached to the minute hand of an electric clock moves over stationary moiré patterns. When the lines superimpose, they create new and interesting patterns. (Photograph by Fortune Monte)

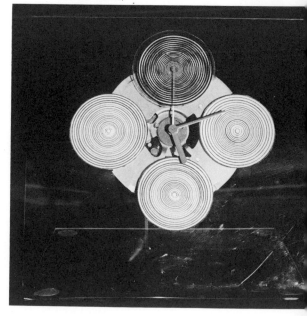

Wind Flowers. A rotating motor creates movement in this flower arrangement made of wire and tin cans. Brazing was used to join the metal forms. (Photograph by Fortune Monte)

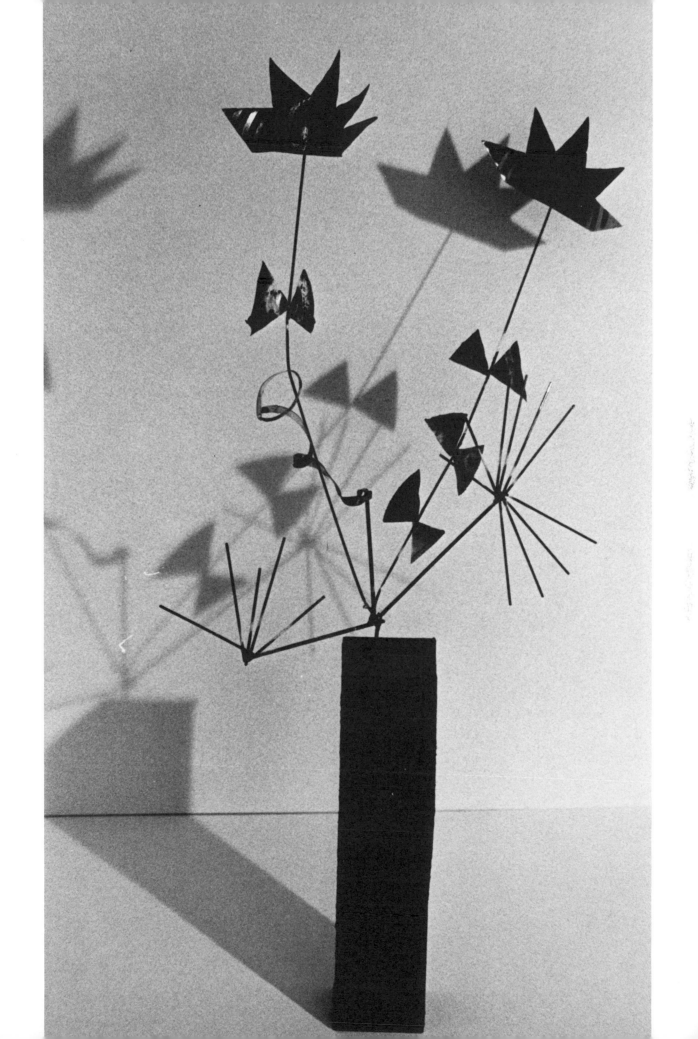

Feather Storm. A concealed electric hair dryer supplies the air currents that circulate feathers in this sculpture. (Photograph by Fortune Monte)

WATER SCULPTURES

A pump, which can move either liquids or air, is an adaptable device which can be used in a variety of ways in your kinetic sculpture. Motion in water is always fascinating to observe. Electric pumps can be obtained from the following sources: discarded aquarium, dishwasher, or washing machine pumps, scientific supply companies, and electric motor supply companies.

To begin, experiment to see what your pump will do. Will moving water or will air bubbles be a material in your sculpture? Will the medium flow through the sculpture? Perhaps it will activate soapsuds? Will colored water be added to heighten the effect?

After you decide what action your pump will perform, consider how you can best develop this into a kinetic sculpture. Whenever water is used, it is important that all containers are carefully constructed so that they are watertight.

RECYCLING PUMP

Inspiration for this sculpture came as a result of a student field trip to an exhibit of sculptural fountains. This student was intrigued with the recycling of water in these sculptures. Coincidentally, her parents were discarding an old dishwasher, and she salvaged the motor and recycling pump. This sculpture, a commentary on modern machinery, conveys a feeling of disorder and disintegration. Its dismembered parts are deliberately assembled so that each material is exposed for what it is, to exaggerate the feeling of disorder.

dishwasher recycling pump and motor
rubber tubing
assorted found objects
½ in. plywood
screws
plastic tubing
electric saw
rolling casters
polyurethane foam
epoxy cement
bathroom sink
nails

This sculpture uses found objects which have significance by themselves, such as a sink, hair curlers, and washing machine parts. Rubber tubing transports the water, while the sink collects and drains it.

To create the feeling of soap and suds, polyurethane foam was used. This is a liquid plastic which expands when activated and then becomes a rigid material. The constantly circulating water which creates motion in this sculpture was tinted blue.

Because of its size, this sculpture was mounted on a base with casters so that it could be easily moved. The motor and pump were concealed in the base to provide a hidden source of power.

AQUARIUM PUMP WITH BUBBLES

The growing soapsuds provide the kinetic excitement in this sculpture (see page 49). The bubbles expand slowly and overflow. Eventually, when the motor is turned off, the soapsuds disappear and the sculpture returns to its original state.

Soapsuds, which are so common in everyday life, are used here in an unusual way as an art material.

clear and opaque acrylic sheeting
fish tank pump
colored ink
liquid acrylic cement (ethylene dichloride)
liquid dishwashing soap
caulking cord
electric saw
drill

A fish tank pump was obtained and the sculpture was planned around it. The design was intentionally kept simple, with a minimum of joinings. It was vital that this sculpture be watertight and that all seams fit closely. The parts were carefully measured and cut with an electric saw. They were joined together with liquid acrylic cement; to prevent leakage, caulking cord was added to the inner seams. The water was tinted purple with colored ink.

SAFETY PROCEDURES

Electrical sculptures may range from the very simple to the highly technical. The kinetic sculptures used in this chapter required only minor electrical work. Students who had experience with electricity assisted. When a problem arose, the help of the school custodian or electricity teacher was enlisted. It is important to stress safety procedures from the beginning of the year. Some precautions to observe are:

1. Overheating in light sculptures can be avoided by venting all enclosed spaces which contain heat-producing light. A few holes drilled into the box will permit free air circulation.

2. Light sources should not be placed too close to any material that might burn or warp from the heat.

3. Any plugs with loose, corroded, or badly bent prongs or a cracked plug body should be replaced.

4. Frayed cords should not be used until all frayed parts have been removed.

5. Avoid fire hazards by checking old lamp sockets, before using, to make sure they are not defective. Loose screws or broken wires are often the culprits.

Recycling Pump.

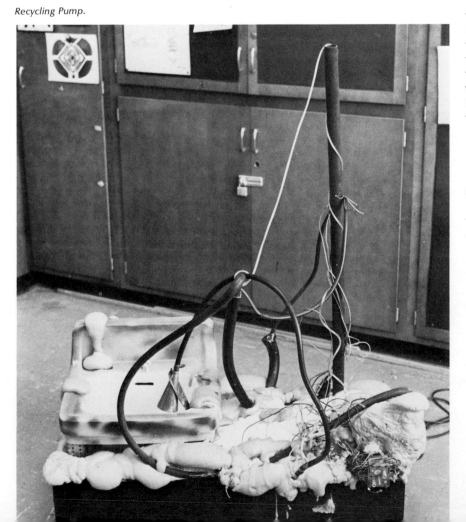

Articulate Man.

Dancing Man. *The viewer is invited to participate in this playful sculpture by pulling knobs. These control the action of the Masonite figure in the plastic box.*

Hydraulic Pump and Blue Water.
(Photograph by Fortune Monte)

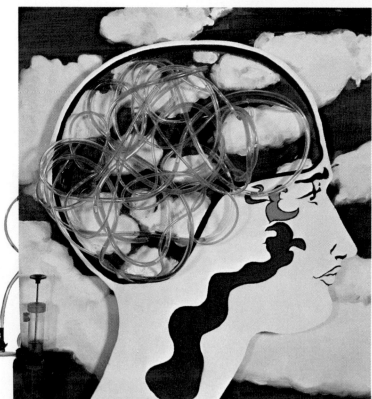

chapter 6
Mechanical Approaches

Mechanical sculptures are meant to be operated by the spectator. They ask for more than just his passive viewing and appreciation. He activates springs, turns cranks, pushes levers, and operates pulleys. He pumps water, starts pendulums, and sets gears, sprockets, and wheels into action. All of these mechanical contrivances produce energy for the creation of movement or sound. They are capable of doing work and returning to their original position.

Mechanical sources of energy may be obtained from a scientific supply company or the following: old dolls, windup toys, building toys (Erector sets have gears, pulleys, wheels, cranks, hoisting units, and springs), clocks, music boxes, metronomes, clothesline pulleys, blocks and tackle, fishing reels, air and water pumps, etc.

To begin, decide what role you want the spectator to play. This will depend on the type of mechanism you select. Especially in mechanical sculpture, the viewer becomes an important part of the total concept of the work. It cannot function without him. What effect will your sculpture have on the viewer? Will it amuse him? Will it be an aesthetic game that intrigues him? Will it be a commentary on man and society? Will it surprise or shock him? Will its movement be irregular or predictable?

ARTICULATE MAN

This playful sculpture moves its head from side to side and makes a strange noise (see opposite). It is controlled by a mechanism which the viewer activates by pushing a button. Coiled pipe cleaners for the hair add to the sense of movement, making this an amusing sculpture with a robot-like quality.

cigar box
epoxy cement
papier-mâché
doll mechanism with noise
drill
acrylic paint
clear plastic spray
hand saw
gesso

An opening was cut in one side of a cigar box. The neck of the push-button mechanism was inserted so that it protruded above the cigar box. A papier-mâché head was made and attached to the exposed section of the mechanism. A hole was cut in the cover of the box to accommodate the push button. The cover was then cemented in place. Gesso was then applied on the outside surface of the box to provide a smooth ground for painting. The entire surface was painted in a decorative design with colorful acrylics. Finally, coiled pipe cleaners were attached to the papier-mâché head.

MECHANICAL CLOCK AND MAN

A discarded alarm clock was the inspiration for this sculpture whose subject is man and his relationship to time. The working mechanism of this windup clock is exposed and the movement of gears can be seen. The pictures on the clockface evoke the growth of a man through the various stages of life. A

Mechanical Clock and Man.

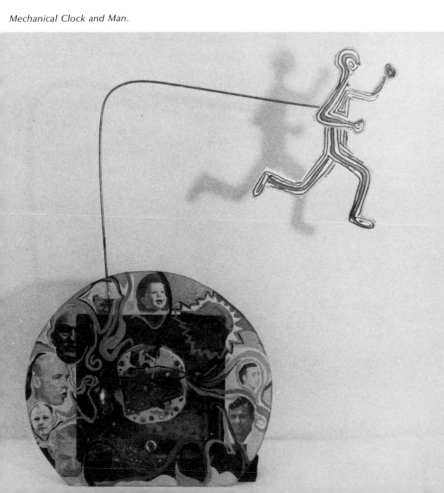

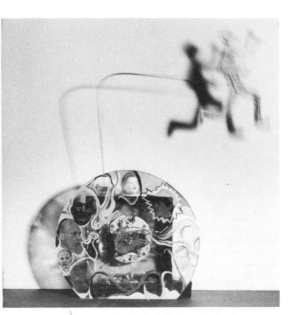

Mechanical Clock and Man (in motion).

symbolic figure of man is attached with a wire to the alarm mechanism; the figure runs whenever the alarm rings; man is seen as a figure controlled by time.

working alarm clock
wire
magazine photos
clear acrylic sheeting
drill
polymer medium
acrylic paint
wood
epoxy cement
electric saw
cardboard

The original clockface was removed for the sculpture and a new clockface was designed. Magazine photos were transferred on to clear plastic with polymer medium. Acrylic paint was used to complete the design. The plastic face was attached to the clock mechanism and the clock hands were remounted. The stylized figure of a man was attached to the wire, which in turn was cemented to the alarm lever of the clock.

MAGNETIC MOVEMENT

Metal filings crawl and rise as the spectator moves a rod in this magnetic sculpture. Constantly changing patterns are formed as the metal filings gracefully rearrange themselves.

horseshoe magnet
epoxy cement
iron filings
plastic rod
clear and opaque acrylic sheeting

The magnetic movement of metal filings was the inspiration for this sculpture. A boxlike shape was constructed with two compartments (see diagram).

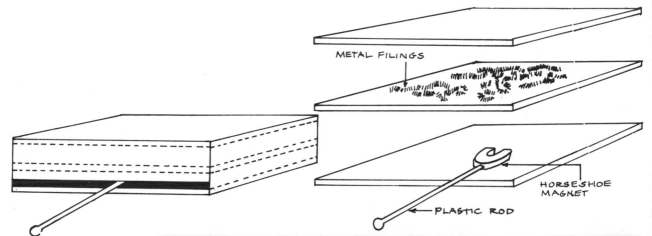

Diagram showing construction of *Magnetic Movement.*

Magnetic Movement. (Photograph by Fortune Monte)

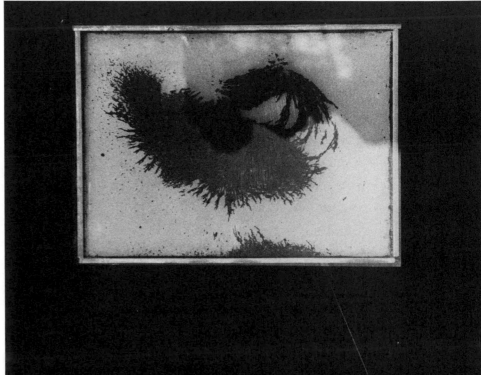

All parts were made of opaque acrylic except for the top which was transparent for viewing. The metal filings were enclosed in the top compartment while the magnet, attached to a rod, was concealed in the bottom compartment. A space was left open at the bottom so that the rod handle could be moved.

HYDRAULIC PUMP AND BLUE WATER

This relief combines painting and sculptural movement (see page 60). A hydraulic hand pump, assembled from a kit, causes the blue liquid to circulate throughout the plastic tubing in the head. There is a feeling of pulsating life in this sculpture which is activated by the viewer, as he operates the pump.

 Masonite
 acrylic paints
 gesso
 epoxy cement
 plastic container
 hydraulic pump kit (Educational Resources, Inc., Orange, New Jersey)
 nails
 wood dowels
 electric saw
 blue liquid
 clear plastic tubing
 drill

The design for this sculpture was carefully planned and sketched. It was to be a painted relief with two levels. The shapes were cut with an electric saw and holes for the plastic tubing were drilled. After the painting was completed, and the two parts assembled, the plastic tubing was set into position and cemented. The pump was assembled and connected. It was decided to make the pump a part of the total design by placing it on the front surface of the relief.

The Moving Eye. This fantasy construction in shimmering silver is a study in contrasts. A rough Sculpt-Metal hand holds a magnetic ball on a string; the ball hovers over an eye held in a smooth silver mannequin's hand. (Photograph by Fortune Monte)

PULL-MOTION MAN

This humorous sculpture talks to the viewer in a strange voice. Its arms swing up and down. The large blue eye opens and closes. This man of eyes is constructed with a simple pull device, a talking mechanism, and a miniature window shade. It requires total involvement on the part of the spectator, who creates the action in this sculpture.

Masonite
string
canvas
gesso
dowels
electric saw
epoxy cement
talking mechanism
found objects
acrylic paint
wood blocks and knobs
drill
heavy duty paper fasteners

The design for this sculpture began as a quick sketch. It was then developed further, and plans were made for the moving parts (see diagram). Each mechanical device had to function independently, yet be compatible with the total design.

The Masonite was cut, gessoed, and painted. Some parts were cemented into place. It was decided that a simple window shade device would move as an eyelid. A hole was drilled in the front of the sculpture to accommodate the pull-ring of the talking device. The arm mechanism was designed to swing on a large dowel. Holes were drilled in the arms for strings and paper fasteners.

Pull-Motion Man (two views). (Photograph by Fortune Monte)

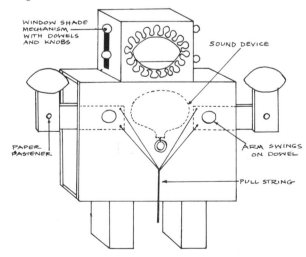

Diagram of construction of *Pull-Motion Man*.

WINDOW SHADE MECHANISM WITH DOWELS AND KNOBS

SOUND DEVICE

PAPER FASTENER

ARM SWINGS ON DOWEL

PULL STRING

Political Music. The artist's individual feelings are expressed in this sculpture which contains a music box. The tune played is "Three Blind Mice." (Photograph by Fortune Monte)

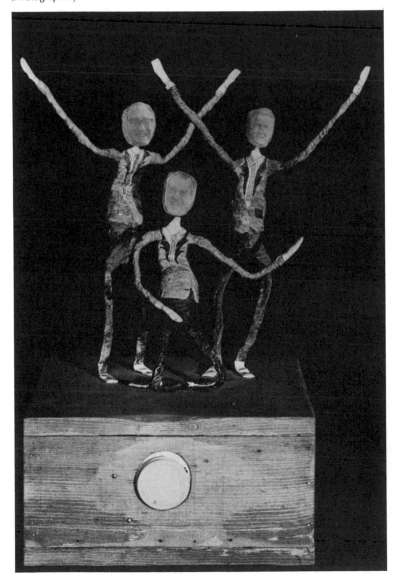

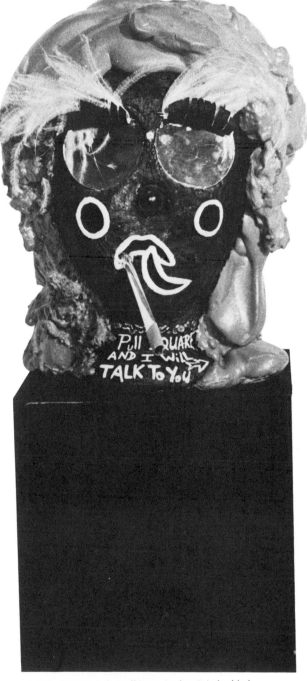

Female Chatter. A fast-talking voice box is imbedded in the Styrofoam head of this sculpture. The viewer is invited to pull a string which controls the sound device. The material used for the hair is polyurethane foam. (Photograph by Fortune Monte)

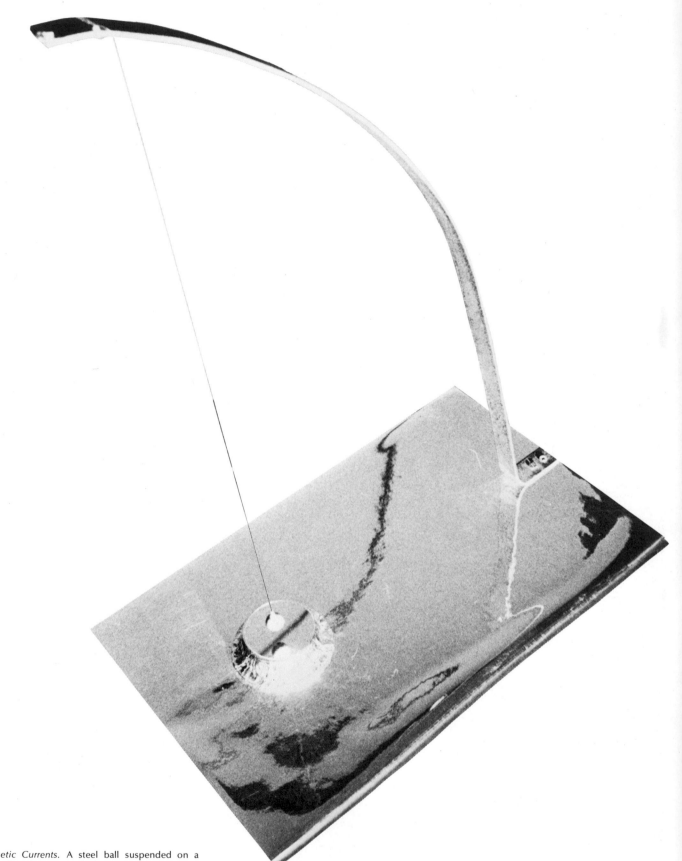

Magnetic Currents. A steel ball suspended on a nylon thread moves in rhythmic patterns over concealed magnets. (Photograph by Fortune Monte)

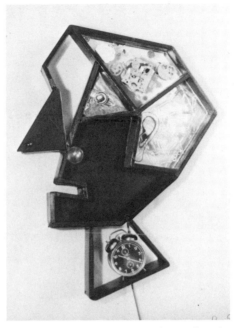

Pendulum Motion. Mirrors and a Mylar dome bounce reflections as this sculpture moves back and forth. The pendulum swings on a pivot and is balanced by a suspended weight. A touch of the hand is needed to set this sculpture into action. (Photograph by Fortune Monte)

The Thinker. The viewer is invited to explore the many small compartments in this sculpture which is a commentary about man and time. He winds clock gears so they tick and turn mechanically. A working clock in the neck provides accurate time, while a flashing red bulb serves as the eye.

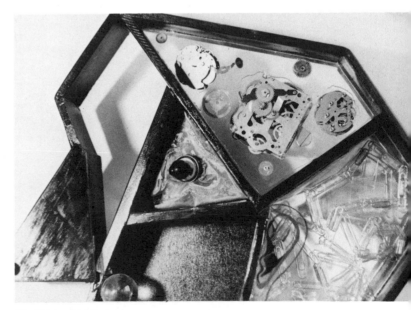

The Thinker (detail view).

chapter 7
Natural Approaches

Natural phenomena such as air currents, temperature changes, and gravity are the forces which activate natural kinetic sculptures. Sometimes the touch of a hand is needed to set them in motion. Movement can follow patterns or be unpredictable as the sculpture rotates or vibrates in space.

To begin, imagine how your sculpture will move. Think about movements in nature: swaying branches and flowers, floating leaves, the graceful motion of birds and fish. Think about movements that are humorous and playful.

Will your sculpture be suspended, will it float in space, or will it be fixed to a base? Some parts of your sculpture might be stationary while others move. Your sculpture can be designed so that one part activates another, causing a chain reaction.

Decide on your materials. Will they be transparent or solid? Will you use mirrored materials for reflections? Will your sculpture use natural or abstract forms?

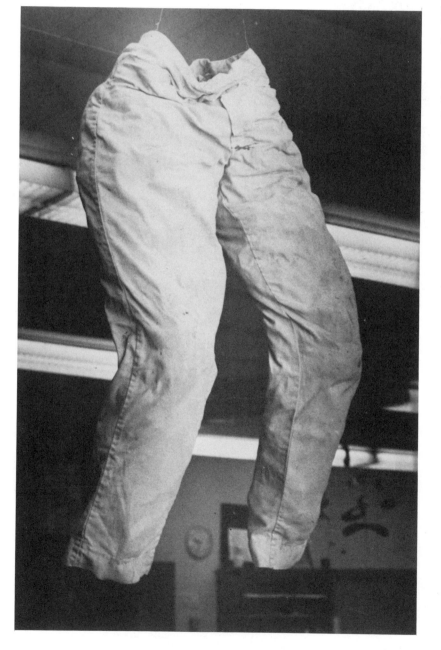

HANGING SPACE PANTS

The startling appearance of this sculpture is created by the realistic impact of the trousers — they seem to contain an invisible body suspended in space. A strong breeze creates a new mood as it makes the sculpture playful — hopping and dancing in air.

found objects
white liquid glue
wire
newspaper

In this sculpture, white glue was mixed with a small amount of water to a consistency that would penetrate the fabric. The trousers were then soaked for several minutes in this glue solution. They were removed carefully, allowing the glue to remain. Newspapers were stuffed into the trousers so they appeared to contain a human form and the trousers were propped into the desired position. When dry, they stiffened and retained their shape. The trousers were suspended in space with wire.

PIVOTAL CONSTRUCTION

A pivotal sculpture invites the observer to transform it by changing one part or another. Because of this, the spectator plays an important role, since he can control its positions.

wood
steel rods
electric saw
hollow plastic rods
sandpaper
wood stain
drill

The design for this sculpture evolved through experimentation with paper shapes. Planning beforehand, in drawings and then cut paper, was a necessity. The design had to work well in all directions and pivot smoothly so that one part did not interfere with another.

When a workable design was found, the shapes were transferred and cut out of the appropriate material. Materials and construction had to be sturdy to withstand handling. The center of balance of each part was determined by resting the piece on a rod until it remained horizontal. Holes were drilled through the wood shapes and a steel rod was inserted through the holes. Pieces of hollow plastic tubing were used to stabilize the position of the moving parts along the vertical steel rod. The entire sculpture was mounted on a wood base.

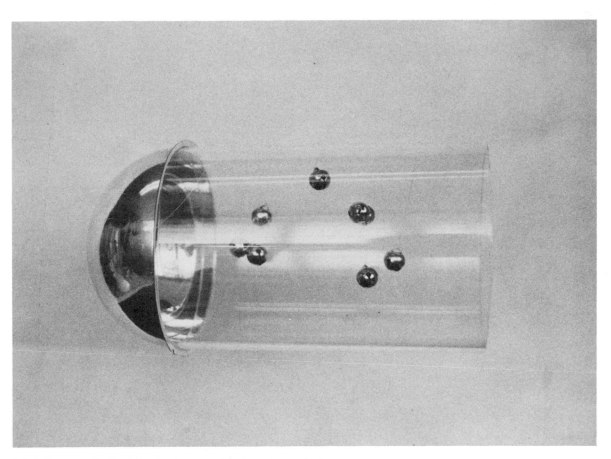

Bells in the Dome. Jingling bells give the dimension of sound to this hanging plastic space sculpture. As the sculpture turns, a Mylar dome reflects and distorts the surrounding environment.

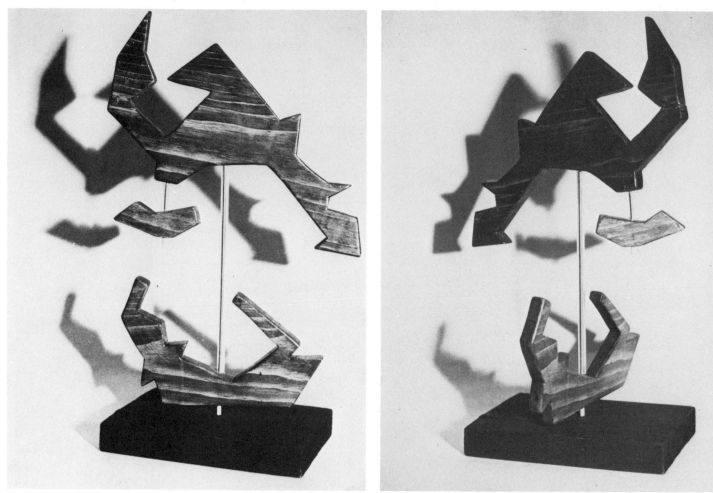

Dynamic Changes (two views).

Pivotal Forms.

VIBRATING METAL SCULPTURE

Vibrating kinetic sculptures have patterned movement as part of their design. They can be set in motion by an air current or the touch of a hand. When they are pushed in one direction they automatically return to their original state.

 metal rods
 metal
 epoxy cement
 wire
 wood
 drill
 tin cans
 plaster

 colored glass
 brazing materials
 ¼ in. copper foil
 soldering iron
 lead solder and flux
 flooring nails
 glass cutter
 metal shears

Certain materials that vibrate naturally can be used in sculpture. Thin metal or plastic rods, when attached to a fixed base or object, will move in this manner. The rods should be rigid, with a spring-like quality. These sculptures can be brazed, soldered, or cemented, depending on the materials used. To join steel rods, tin cans, or nails, brazing is recommended. Soldering can be used for other metals such as copper, tin, and galvanized iron or wire. All materials attached to the metal or plastic rods must be lightweight so that the rods remain upright. When colored glass is used, it should be thin and in the style of Tiffany glass; its framing should be made of thin copper foil, rather than the usual leading.

A hole or series of holes should be drilled in the base to accommodate the rods which are then cemented into place with epoxy glue.

Dancing Figure with Moving Parts. (Photograph by Fortune Monte)

Swaying Space Flowers.

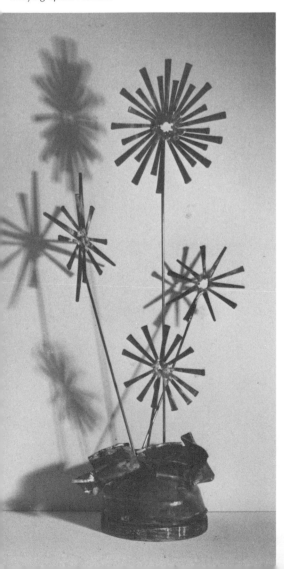

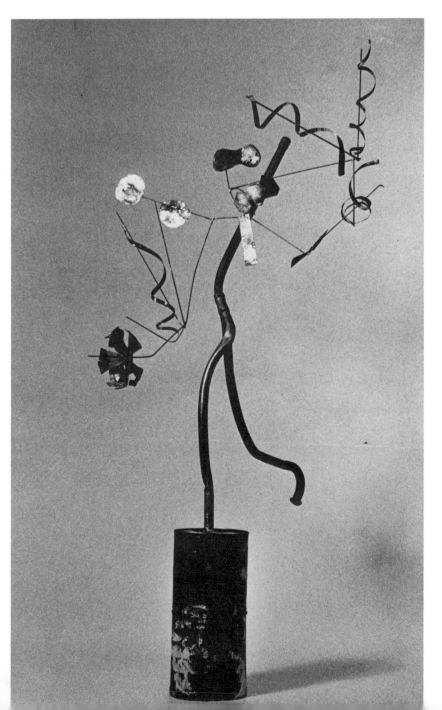

STAINED GLASS IN SPACE

Wire and stained glass in the Tiffany style were the basic materials for these sculptures. The use of stained glass in moving sculpture permits light to create colorful patterns and shadows, which become part of the total design.

electric saw
drill
wire
epoxy cement
colored glass
lead solder and flux
soldering iron
¼ or ⅝ in. copper foil
steel welding rod
glass cutter
metal shears
wood stain
wood

Glass sections were cut and enclosed in copper foil. It is important to bend the foil so that equal amounts appear on the front and back of the glass. Lead solder, applied with a soldering iron, was then used to cover the copper foil and join the seams. The finished glass form was attached with links and soldered to a shaped steel rod. The rod should be made of rigid but flexible material.

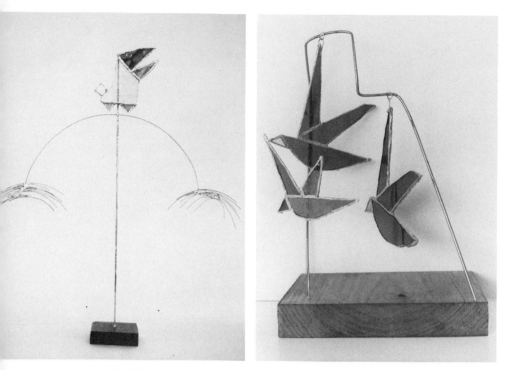

Swinging Bird. This stained glass bird in the Tiffany style vibrates when any part of the wire sculpture is touched.

Birds in Flight.

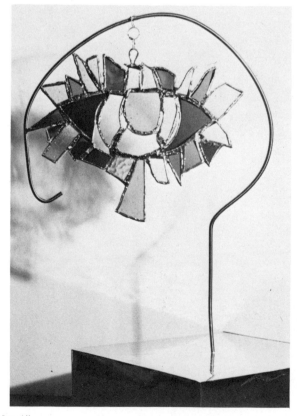

Eye See All.

Fish in Motion. (Photograph by Fortune Monte)

72

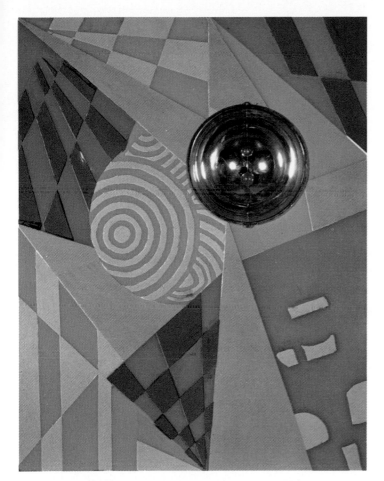

Ball In Reflecting Dome. *A ball is suspended in a concave Mylar dome which reflects multiple images when the ball moves. (Photograph by Fortune Monte)*

Crystal Patterns. *(Photograph by Fortune Monte)*

chapter 8
Chemical Approaches

We did much research on the subject of chemical changes in matter and their potential for sculptural exploration. We discovered that very little has been produced in this area by professional artists. Our students undertook extensive experimentation and attempted countless sculptures. After much discussion, evaluation, and consultation, we came to the conclusion that chemical crystals, of both types shown here, were the best and safest chemical materials for creative expression at this level.

Some chemical crystals are easily available and are simple to work with. They can change at minimal heat from solids to liquids, vapors to crystals. The resulting patterns are spectacular as they splinter and spread in all directions. Crystals can be grown in glass containers or between thin sheets of glass.

Crystal slides can be made and used with polarizing filters to project moving and changing color effects. Encapsulated liquid crystals, available in sheets, are another form of crystal. They respond to various degrees of heat by changing color. Some of these crystals react to body heat and change dramatically when touched with a finger.

Chemical materials can be obtained from the following sources: the school science department, hardware stores (moth crystals), or scientific supply companies.

To begin, some experimentation is necessary to see the effects created by changing chemical crystals. Thought should be given to the glass forms needed to contain the growing crystals. It is important that your completed sculpture does not resemble a chemistry experiment.

Decide what you will use to produce change in your sculpture. Will heat be necessary? Think about the possibility of an outdoor crystal sculpture. What materials can be used to make it durable? Is color an important part of your sculpture?

If you use encapsulated liquid crystals, decide how the viewer will be invited to touch a sculpture made of this material.

CRYSTAL PATTERNS

Fascinating patterns form inside glass as crystals respond to temperature changes in their environment (see page 73). Sunlight, or heat produced by electric light, causes the crystals to liquefy and vaporize, in cycles. The effect is intensified with the addition of color.

 opaque acrylic sheeting
 spotlight
 glass molds
 paradichlorobenzene crystals
 naphthalene crystals
 epoxy cement
 frosted tempered glass sheet (Pyrex)
 electric saw
 colored ink

Experimentation with easily obtainable crystals such as paradichlorobenzene or naphthalene (commonly used for moth control) led to the construction of this sculpture. Change in the structure of these crystals is rapid and occurs at a low-heat temperature. It was necessary, therefore, to decide on a source of heat before planning the design. This sculpture was constructed to use electric light. Sunlight could be used as an alternate heat source. Some sculptures can be planned for sunny windowsills or for the outdoors, giving thought to heat intensification techniques. This particular sculpture was not practical for the outdoors because of the fragile nature of its materials.

Plastic was used for three sides of the base. The back was left open for maximum ventilation. Because of the concentrated heat of the light bulb, which shattered ordinary glass, it was necessary to use Pyrex glass for the top surface of the base. Pyrex glass was unavailable at the local glassworks; it was obtained from a nearby distributor, recommended by Corning Glass in Ithaca, New York.

Crystallization was allowed to take place in the glass containers which were placed over the light source. Colored ink was added at all stages of crystallization—solid and liquid—in order to observe the different effects. The forms were then cemented to the base with epoxy.

LIQUID CRYSTAL COLOR RESPONSE

Mysterious color changes occur when the viewer touches the encapsulated liquid crystals used in this relief sculpture (see page 76). A hidden message, in one of the hands, adds to the interest, as it becomes unexpectedly visible. The spectator is encouraged to effect the change in this sculpture, making it a two-way communication.

 mirrors
 epoxy cement
 cardboard
 found objects
 felt pen
 colored paper
 acrylic paints
 clear acrylic sheeting
 wire
 clear tape
 encapsulated liquid crystals (Edmund #500224, #500274)

It was important to plan a design which would tempt the viewer to touch this sculpture. A fantasy figure was assembled using mirrors, in which the observer could see himself reflected. Written instructions direct the viewer to create "eyes" with his fingers, by touching the liquid crystal mask attached to the face. With body heat, these crystals change from green to dark blue. In addition to changing color — from black to green — when touched, one of the hands reveals a word. Cardboard letters were placed between the liquid crystal hand and the background support. When the spectator presses his hand upon the hand in the sculpture, the message appears.

A design was painted behind the clear acrylic background and bright colored paper was added, to complete the relief.

SAFETY PROCEDURES

Chemical compounds can be potentially hazardous, if used constantly and in large quantities. Sometimes, when rather extensive work is done with chemicals (for example, mixing polyurethane foam in large amounts) maximum ventilation is required. In those cases, it is a good idea to move to a chemistry laboratory or outdoors. In most of the student sculptures in this book, however, small amounts were used in a limited way. We observed certain precautions in the art room:

1. Adequate ventilation should be provided for students using liquid acrylic cements, epoxies, chemical crystals, aerosol sprays, etc.

2. Students with allergies should be cautioned about handling these materials.

3. Avoid skin contact when using toxic materials. Encourage students to wear gloves and to wash thoroughly with soap and water if contact occurs.

4. It is essential to read directions and labels of caution carefully when using chemicals.

Liquid Crystal Color Response. *(Photograph by Fortune Monte)*

Sources of Supplies

Below is a list of materials useful for kinetic sculpture and some of the suppliers. The widest selection of supplies can be found at the Edmund Scientific Company, 403 Edscorp Building, Barrington, New Jersey 08007. They have an excellent catalog and will supply small quantities of a specific item for schools.

It is a good idea to explore all local sources before contacting a large manufacturer. Some industrial companies sell only in large quantities. They will, however, supply the names of distributors in your local area, upon request. If you encounter a problem, or have a question about a particular product, they are usually most helpful.

Adhesives

local hardware stores, art supply stores, hobby shops

Borden Chemical, Division of Borden, Inc., 350 Madison Avenue, New York, New York 10017

Devcon Corporation, Danvers, Massachusetts

DuPont Company, Wilmington, Delaware 19898

Bells, Buzzers, and Chimes

local variety stores, pet shops, electrical, or hardware stores

Bevin Brothers Manufacturing Co., P.O. Box 60, East Hampton, Conn. 06424

Shigoto Industries, Ltd., 350 5th Avenue, New York, New York 10001

Chemical Crystals

local hardware stores, school chemistry laboratory

Liqui-Crystal, Inc., 111 East Market Street, York, Pa. 17401

Colors and Dyes

local craft shops, art supply stores, variety shops, and supermarkets

Aljo Manufacturers, 116 Prince Street, New York, New York

James B. Day Co., Carpenterville, Ill., 60110

Electric and Electronic Equipment

local hardware stores or electric-electronic suppliers

Audio Visual Communications, Inc., 159 Verdi Street, Farmingdale, New York 11735

Lafayette Radio, 111 Jericho Turnpike, Syosset, New York 11791

Radio Shack, P.O. Box 1052, Fort Worth, Texas 76101

Feathers

Charles Zucker Corporation, 31 Mercer Street, New York, New York

Plume Trading and Sales Company, Inc., P.O. Box 585, Monroe, New York 10950

Glass

Local glass suppliers

S.A. Bendheim Co., 122 Hudson Street, New York, New York (colored glass)

American Handicrafts Co., 1001 Foch Street, Fort Worth, Texas 76107 (glass molds)

RPH Manufacturing Co., 24 Winter Street, Stamford, Conn. 06905 (glass molds)

Corning Glass and Co., Ithaca, New York (Pyrex glass)

F.J. Gray and Co., Inc., 139-24 Queens Blvd., Jamaica, New York 11435 (Pyrex glass)

Lasers

Plasma Systems, P.O. Box 3261, San Jose, California 95116

Lighting Supplies

local theatrical equipment companies, electrical supply or hardware stores

General Electric — Lamp Division, 219 East 42 Street, New York, New York 10017

Stroblite Co., Inc., 29 West 15 Street, New York, New York 10011

Motors (fountains, pumps, fans, bubble-making machines)

local electrical supply stores, hobby shops

Better Bubbles, Inc., North Hollywood, California

Canal Electric Motor, Inc., 310 Canal Street, New York, New York 10013

Neon

local neon sign makers (to fabricate neon tubing from artist's design)

Niemeyer Signs Co., Inc., 121 Bay Avenue, Patchogue, New York 11772

Optical Supplies

local opticians surplus stores

Bausch and Lomb, 635 St. Paul Street, Rochester, New York 14602

Plastics

Amplast, 359 Canal Street, New York, New York 10013

Castolite Liquid Plastics, Castolite Co., Woodstock, Illinois 60098

Industrial Plastics, 324 Canal Street, New York, New York 10013

Polyproducts Corporation, 13810 Nelson Avenue, Detroit, Michigan 48227

Polarized Light Materials

Polacoat, Inc., 9750 Conklin Road, Cincinnati, Ohio 45245

Polar Manufacturing Corp., Drawer B, 112 Parkway Drive South, Hauppauge, New York 11787

Films, Filmstrips, and Slides

Rubber Supplies

Canal Rubber Supply Co., 329 Canal Street, New York, New York 10013

Surplus Stores

Canal Street General Store, 312-316 Canal Street, New York, New York 10013

C.K.&L. Surplus Co., 305 Canal Street, New York, New York 10013

Bob Michaels Surplus Corp., 307 Canal Street, New York, New York 10013

Catalogs and Magazines (for further sources)

Playthings, Geyer-McAllister Publications, Inc., 51 Madison Avenue, New York, New York 10010

Popular Mechanics

Popular Science

Films

Alexander Calder: Engineer in Space. 59 minutes. Indiana University Audio Visual Center, Bloomington, Indiana, 1963.

Alexander Calder: From the Circus to the Moon. 15 minutes, color. Contemporary Films, McGraw Hill, New York.

Alexander Calder: Sculpture and Constructions. 10 minutes, color. Department of Film Circulating Programs, Museum of Modern Art, New York, 1944.

Art for Tomorrow. 25 minutes, color. Kent State University Audio Visual Center, Kent, Ohio.

Calder's Circus, 19 minutes, produced in France. McGraw-Hill, New York, 1963.

Homage to Jean Tinguely. 11 minutes. Cinema 16 Film Library, Grove Press, New York, 1962.

Joys of Kinetic Art. 22 minutes, color. Daneli International Films, Inc., Santa Barbara, California.

Link. 11 minutes, color. Produced by the British Film Institute, London. Films Inc., Wilmnette, Illinois.

Magic Machines. 14 minutes, color. Learning Corporation of America, New York, 1970.

New Arts (Expo 70 Osaka, American Pavilion). 16 minutes, color. Visual Resources Inc., New York, 1972.

Play With Light and Color. 9 minutes, color. Film Images, New York, 1971.

See, Touch, Feel. 29 minutes, color. Sterling Films, Educators Progress Service, Inc., Randolph, Wisconsin.

Sonambients: The Sound Sculpture of Harry Bertoia. 16 minutes, color. Museum of Modern Art, New York, 1971.

Sort of a Commercial for an Icebag. 16 minutes, color. Museum of Modern Art, New York, 1970.

Trojan Horse. 28 minutes. The Metropolitan Museum of Art, New York, 1968.

Works of Calder. 20 minutes, color. Museum of Modern Art, New York, 1950.

Filmstrips

Kinetic Art. #614, 15 minutes, color and sound, record or cassette. Educational Dimensions Corp., Stamford, Connecticut.

Slides

Kinetic Sculpture by George Rickey. Set of 30 slides. Prothmann Associates Inc., Baldwin, New York.

Science, Technology and the Modern Artist. Set of 16 slides. Art and Man (Series), Scholastic Magazine (under the direction of the National Gallery of Art), Englewood Cliffs, New Jersey.

Bibliography

More Books to Explore

Brett, Guy. *Kinetic Art*. New York: Van Nostrand Reinhold, 1968.

1973 Britannica Yearbook of Science and the Future. Chicago: Encyclopedia Britannica, Inc.

Buckwalter, Len. *Electronic Games and Toys You Can Build*. New York: The Bobbs-Merrill Co., Inc., 1970.

Burnhan, Jack. *Beyond Modern Sculpture, The Effects of Science and Technology on the Sculpture of this Century*. New York: Braziller, 1968.

Davis, Douglas. *Art and the Future*. New York: Praeger Inc., 1973.

Feldman, Edmund Burke. *Art and Image*. Englewood Cliffs, New Jersey: Prentice-Hall, Inc., 1967.

Holden, Alan and Singer, Phyllis. *Crystal and Crystal Growing*. Garden City, New York: Anchor Press, 1960.

Hulton, K. Pontus. *The Machine*. New York: The Museum of Modern Art, 1968.

Jones, Tom Douglas. *The Art of Light and Color*. New York: Van Nostrand Reinhold Company, 1972.

Kluver, Billy and others. *Pavilion Experiments in Art and Technology*. New York: E.P. Dutton and Co., Inc., 1972.

Kultermann, Udo. *The New Sculpture*. New York: Praeger Inc., 1968.

Michel, John. *Small Motors You Can Make*. New York: Van Nostrand Reinhold Company, 1963.

Newman, Thelma R. *Plastics as an Art Form*. Philadelphia: Chilton, 1964.

Oster, Gerald. *The Science of Moiré Patterns*. Barrington, New Jersey: Edmund Scientific Company, 1969.

Palestrant, S. *Toymaking*. New York: Homecrafts, 1951.

Popper, Frank. *Origins and Development of Kinetic Art*, Greenwich, Connecticut: New York Graphic Society, Ltd., 1968.

Reichardt, Jasia. *Cybernetic Serendipity*. New York: Praeger Inc., 1969.

Roukes, Nicholas. *Sculpture in Plastics*. New York: Watson-Guptill Publications, 1968.

Selz, Peter. *Directions in Kinetic Sculpture*. Berkeley, California: California University of Art Museum, 1966.

Shurcliff, Wm. A. and Ballard, Stanley S. *Polarized Light*. Princeton, New Jersey: D. Van Nostrand Company Inc., 1964.

Tovey, John. *The Technique of Kinetic Art*. New York: Van Nostrand Reinhold Company, 1971.

Tuchman, Maurice, *A Report on the Art and Technology Program of Los Angeles County Museum of Art*. Los Angeles: Los Angeles County Museum, 1971.

Unique Lighting Handbook. Barrington, New Jersey: Edmund Scientific Company, 1969.

Catalogs

Aaronel de Roy Gruber, Kinetic Sculpture. New York: Bertha Schaefer Gallery, 1971.

Baschet. New York: Waddell Gallery, 1971.

Bauermeister. New York: Galeria Bonino, Ltd., 1967.

Electric Art. Los Angeles: Catalog of Exhibition at UCLA Art Galleries, 1969.

Feliciano Bejar Magiscopes. New York: Bertha Schaefer Gallery, 1968.

John Healey, Sculptures in Light. New York: Waddell Gallery, n.d.

Nicholas Schoffer. New York: Galerie Denise René, 1972.

Pol Bury. André Balthazar, 1967.

Pol Bury. New York: Lefebre Gallery, 1966, 1968, 1971.

Tsai, Sculptures Cybernetiques. Paris: Galerie Denise René, 1972.

Unmanly Art, Stony Brook, New York: Suffolk Museum, 1972.

Historical Reference

Encyclopaedia Britannica, 1967 edition, vol. 19, pp. 397–398. Article, "Robots."

McGraw Hill Encyclopaedia of World Art (1960), vol. 2, pp. 182–194, Article, "Automata."

Index